How to design
Logos, Symbols and Icons

How to design
Logos, Symbols and Icons

24 Internationally renowned studios reveal how
they develop trademarks for print and new media

Gregory Thomas

NORTH LIGHT BOOKS

CINCINNATI, OHIO

WWW.HOWDESIGN.COM

To my wife and son for their faith,

and to Kathrin Spohr for her invaluable contribution.

How to Design Logos, Symbols and Icons. Copyright © 2000 by Gregory Thomas. Manufactured in China. All rights reserved. No other part of this book may be reproduced in any form or by any electronic or mechanical means including information storage and retrieval systems without permission in writing from the publisher, except by a reviewer, who may quote brief passages in a review. Published by North Light Books, an imprint of F&W Publications, Inc., 4700 East Galbraith Road, Cincinnati, Ohio 45236. (800) 289-0963. First edition.

Visit our Web site at www.howdesign.com for information on more resources for graphic designers. Other fine North Light Books are available from your local bookstore, art supply store or direct from the publisher.

06 05 04 03 02 7 6 5 4 3

Library of Congress Cataloging-in-Publication Data

Thomas, Gregory
 How to design logos, symbols, and icons : 24 internationally renowned studios reveal
how they develop trademarks for print and new media / Gregory Thomas.
 p. cm.
 ISBN 0-89134-915-4 (alk. paper)
 1. Trademarks—Design. 2. Logos (Symbols)—Design. I. Title.

NC1003 .T48 2000
741.6—dc21 00-037257

Editors: Lynn Haller and Linda H. Hwang
Production Coordinator: Kristen Heller
Cover and interior design by Gregory Thomas

The copyright notices on page 141 constitute an extension of this copyright page.

CONTENTS

Foreword by Earl Powell

President, Design Management Institute
Boston

When Greg Thomas told me he planned to write a book on the design of logos, icons and symbols, I encouraged him, and wished him well in undertaking such a challenge. Greg's goal is to trace the history of pivotal and universal designs, and, in doing so, place them in a historic perspective, explaining what may have gone into their creation, why they are effective, and, more important, what the key lessons are for corporate executives who want to develop their own basis for making logo, icon and symbol decisions.

Over the past ten years, I have witnessed extraordinary changes in the composition and positioning of the business enterprise. Mergers and acquisitions, buyouts and corporate facelifts have impacted not only the persona of the corporation but their symbols, icons and logos as well. They, too, have changed dramatically—to project a changing and more forward-thinking philosophy—or to help with the branding and identification of new, innovative products. Familiar brands such as Ford Motors, General Foods, General Electric—even the U.S. Post Office—have responded to new business challenges and structures. For example, Nike and AT&T have redesigned their signatures. They have new logos that reflect more forward-thinking, diverse corporations that are ready to serve the changing needs of the ever-evolving marketplace.

Greg Thomas knows the design of a corporate symbol must be an effective visual cue representing the core attributes of the organization and thus present a mini-story. It cannot be some hit-or-miss doodle coming from the memo pad of a CEO. In today's marketplace, corporate symbols must be distinctive and communicate effectively with desired audiences. And now, at the dawn of a new millennium, the headquarters for the new enterprise need not be on Park Avenue in New York or Regent Street in London. The rule for the day is anytime, anywhere at lightning speed. These changes demand thoughtful strategic design. Amateur symbols based on casual thinking won't hold up in the intense complexity of today's markets.

In this book, Greg Thomas educates the readers about trademarks, symbols and icons. Then he guides the readers through the thought processes they would witness if they were sitting in the meeting room of legendary corporate logo design agencies such as Saul Bass, Paul Rand and Chermayeff & Geismar. For over twenty years, Greg Thomas has specialized in corporate communications and identity programs. His knowledge is invaluable—his grasp and understanding of the design field is profound. All his years in design are in this book for readers to see and learn from. New leaders can gain a wealth of valuable insight for positioning and presenting their companies.

I congratulate Greg for his thoroughness and dedication. His book is a must-read for every competitor in the new millennium.

Introduction

2,000 Words on 2,000 Years of Logos, Symbols and Icons

Take a walk down a supermarket aisle and look at the enormous array of products. Chances are, you'll recognize what most of them are or do just by their packaging. Certain pet-food products have checkerboards that "red flag" the purchaser. A detergent's orange and yellow swirls promise a tornado of cleaning power. Hundreds of soup cans stand at attention like an army, wrapped in red and white labels wearing a world-famous signature. A company with ten different types of pasta packages their products in bright blue cardboard boxes with see-through windows—each one a mini-billboard that describes the contents and tells the company story in an instant. If these descriptions prompted you to think of Ralston Purina, Tide Detergent, Campbell's Soups and Ronzoni Pasta, then the company branding is achieving its desired recognition factor.

Afterward, go out and look at the billboards that beckon to you from all around. Notice the colorful graphics that are blown up much larger than life on the sides of buildings—sometimes six stories high. Or simply open a magazine or turn on your television and you'll recognize a common theme to the advertisements—all of them have an identifiable "signature," a graphic that means instant recognition. Apple Computers, Nike, The Gap, MasterCard, Hertz, Avis, American Express, the Bank of America—they're all different but they all have one thing in common, a very familiar trademark.

Trademarks are prehistoric. They began as symbols of personal and group beliefs and evolved from the desire and need for social communication and identification of certain "truths." Take something as basic as the circle; it was used to signify the endlessness of the universe. And it also meant eternity or God.

Circles are amongst the oldest "ads" and belong to the oldest ideograph symbols. Found on the walls of pre-Columbian caves, they have been drawn and painted empty and filled. An empty circle, while meaning eternity, could also indicate, among primitive people, openings such as eyes or a mouth; a circle with a point or dot placed in its center—again, one of the oldest "signs"—would represent the sun and the open eye of a Supreme Being. This ideograph appears to have been used in every cultural sphere on earth, long before communication between civilizations existed.

Other primary forms, such as the cross and triangle, were used to signify God and Heaven joining together on earth. The cross predates Christianity and was one of the earliest signs used by humans during the Neolithic Age. Traces of this simple symbol still exist on walls of prehistoric caves and can be found chiseled into rocks. Conversely, the triangle traces its symbolic importance to its three even sides, which have been used to define a multitude of triads such as birth, life and death or

body, soul and spirit. Pythagoras, the sixth-century B.C. Greek philosopher and mathematician, employed it as a symbol for wisdom. Later on, Christianity used it as the perfect symbol for the Holy Trinity: the Father, Son and Holy Ghost.

The square, on the other hand, stands in direct contrast to the circle. While the circle represents eternity and deity, the square signifies matter and earth. The square stands for restraint, solidarity, order and safety—less ephemeral and much less spiritual.

These simple and primary signs were man's first attempt to communicate, not by tongue, but by a representational drawing or image. Just as verbal communication was beginning, so too was the need to project thoughts in a more concrete form. Words and hand signs faded and could be misconstrued or misinterpreted—images didn't and couldn't. Symbols developed and even began to represent civilizations. For instance, the Roman Empire developed the first nationalistic logo—SPQR, which stood for "Senatus Populusque Romanus," or the senate and the people of Rome. By the fourteenth century, artisans were beginning to employ symbols to identify their creations. Stonemason marks were applied to cathedral walls and castles. Trademarks were stamped into pottery and signed upon porcelain—all in an effort to identify the maker and to attest to the quality of the finished product. Even as far back as the thirteenth century, quality assurance via the use of trademarks became so important and prevalent that English law mandated they be used wherever possible, even on every loaf of bread baked. This allowed the customer to identify the baker or the bakery and help him determine whether to buy the particular "brand" again. Symbols developed into art forms themselves. The German painter Albrecht Dürer's timeless mark, placed at the bottom of all his work, is still

a hallmark for excellence in art. Much later, Paul Revere used a symbol to identify himself as the "maker"—engraved into the base of all his silverware.

By the beginning of the nineteenth century, trademark usage had been strongly established in the New World. Manufacturers saw an excellent opportunity to advertise and promote their products. Procter & Gamble was one of the first companies to capitalize on the usage of trademarks. It all started when they began shipping candles to cities along the Ohio and Mississippi Rivers, and wharfhands would stamp crates with a crude star. The firm soon noticed that customers down river would recognize the star and knew that the container held P&G goods. After they refined the stars and added a thin moon, this symbol became a symbol of quality, and merchants would only accept the "starred" crates.

Other corporate giants recognized the opportunity, and soon Arm & Hammer, Quaker Oats, Coca-Cola and John Deere turned their names into billboards. Patent medicines and tobacco companies then began fostering the use of brand recognition in new areas.

Enterprising merchants became increasingly aware of the importance of branding, and the government was called upon to protect these new emerging symbols by establishing trademark patents. By 1898,

the importance of the trademark as a sales tool was so prevalent that the National Biscuit Company introduced its first cracker with a picture symbol. The Uneeda slicker boy, and later on the Quaker Oats man, became instantly recognizable symbols for their new products.

Signs and logos began appearing everywhere in the marketplace. A signature for Coca-Cola, penned by the company's bookkeeper, adorned the famous bottle and the original red tin signs that hung in front of general stores in the South. William Danforth, the founder of Ralston Purina, developed the now-famous checkerboard square pattern for all of Ralston's packaging. The advertising manager for Sherwin-Williams created the "Cover the Earth" or dripping globe trademark for their paints in 1895.

And in 1914, one of the nation's first advertising agencies, N.W. Ayer, who had helped National Biscuit with the Uneeda boy, developed the classic Morton Salt Girl—the smiling little blond girl clothed in a simple yellow rain slicker who guaranteed the purchaser that Morton's salt "poured like rain."

Eventually advertising agencies were not the only creative forces helping corporations to develop their identities. Corporate identity "specialists" such as Lippincott & Margoles and Raymond Loewy appeared. Loewy developed the first trademarks for International Harvester and TWA—trademarks that have been altered and "face-lifted" but remain constant to this day.

The trademark was quickly becoming a new art form, and designers began to look elsewhere for inspiration. With the rise of the Bauhaus style in pre-war Germany, more abstract symbols began to appear even in America. Symbols of nineteenth-century companies were "freshened up" with a newer, more contemporary and international look. In the 1960s, logos were streamlined again and became even more sophisticated. Chermayeff & Geismer developed the stark, powerful octagonal symbol for the Chase Manhattan Bank. Paul Rand, an early pioneer in contemporary trademark design, repositioned IBM, Westinghouse, UPS and more, all with fewer lines and tighter shapes, and all with powerful, bold graphics.

In the 1970s and 1980s, due to acquisitions and mergers, companies became more diversified and trademark design had to express more unique and complex corporate structures. Independent corporations found themselves subsidiaries of larger parent corporations. It was becoming more difficult to achieve a single overall image to represent the conglomerate. The trend was toward symbols that were less specific and more generic and encompassing. In short, they could mean anything. Arrows pointing out were employed to depict companies on the move; arrows pointed inward represented a company with a central operating base.

New products developed for new lifestyles also needed "umbrella" logos. Fashion needed contemporary, instantly recognizable symbols and Nike and Calvin Klein chose symbols and lettering that would state they designed the products carrying them. Soon Donna Karan, Ralph Lauren and his famous polo player, the Mossimo signature and the familiar Stussy autograph appeared everywhere on clothes, T-shirts—even underwear. Wearers "sported" these upstart names in the same manner as they did Gucci and Levi in earlier decades.

And the message continues for new companies, new designers and manufacturers, new dreamers of a better world. It is clear and simple: our times demand fast, easily recognizable symbols to denote the product and service of the corporation or even the individual maker. Just as Michelangelo, in a

rage, chiseled "Michelangelo made this" into the sash of Mary's robe on the Pieta, manufacturers are finding ways not only to identify themselves and their products but to advertise them. In an age of media clutter and hype, a product must advertise itself, stand alone and contain its origin, source and standard of quality in one word or symbol. But that doesn't mean that a new logo can't be developed without the aid of a company, advertising agency or specialist. History has proven that the ideal trademark—from a marketing viewpoint—must be simple and unique, distinctive and, most importantly, memorable. It must conjure instant association with one particular product or service. It must encourage repeat purchase. It must mean excellence on all levels.

Now, as we begin a new millennium, we can review the successes of this century. We can track the evolution of AT&T from a "homey" and comfortable Liberty Bell surrounded by type to a bold three-letter symbol synonymous with survival, still trusted even after antitrust laws diminished the company's reach. We can trace the CBS eye (and the stylized NBC peacock) from a plain abstraction to a modern elliptical symbol that only suggests its past. American Oil is now Arco, Exxon is now Standard Oil of NJ and a network of railroads has evolved into Amtrak. However, the field is expanding, and now there are even greater opportunities for smaller companies starting out to achieve a "big," quality look. But it means more than just looking back; it means dissecting design, understanding the message and then designing a more meaningful symbol.

The Art of the Mark

How to Design Successful Logos, Symbols and Icons

So you have a new G4 loaded with Ram and you just got a trademark design job. "No problem," you think as you sit before this machine, able to merge or melt the most complicated of all the fonts loaded into your suitcase.

But to design a symbol or trademark, it is important to understand that without a knowledge of typography or drawing, your designs may have the shelf life of an overripe banana.

Listed here are some fundamental applications of drawing and type that should be considered in your compositions.

It is important to realize the visual phenomenon known as "figure ground" or positive and negative forces interacting will always enhance and make your mark unique.

A successful mark is one that engages viewers and allows them to play a small interactive mind game with it. For example, the newly replaced Bank of America symbol incorporated a bird in the letterform, but the bird couldn't be seen by many of the bank's customers. After redrawing and several large television campaigns, BofA was able to delineate the bird (eagle?) in flight. Once the viewer managed to visually "resolve" the puzzle, the mark became a classic symbol of "once you see it, you can't see it any other way."

So where do you start? An analysis of the current logo always needs to be done. The first thing to look for is how much equity the current brand has. It is a smart designer who will not jump at the opportunity to redo a mark such as Coca-Cola. The reason for a redesign varies:

1. New leadership. A new CEO may come in and want his own mark placed on the company.

2. Financial reasons. The company may have undergone reorganization and a new identity will convey (or hide) this—case in point, the newer United Airlines brand.

3. Prospective analysis of the market. Perhaps XYZ company has been doing the same thing for years but now plans to shift its marketing positioning to a new area, and it would like the new image to reflect this.

4. Mergers. Two companies merge to form one.

The graphic designer must find out what the client is trying to accomplish with their logo redesign, and must make recommendations for how these goals might be best accomplished. For instance, my studio was asked to redesign a mark for a large aerospace company. Upon our research we determined that what was needed was not a new trademark, but was instead a graphic system that brought all the divisions together. One might have thought we shot ourselves in the foot, but instead we won the respect and admiration of the company for years to come.

"A successful mark is one that engages viewers and allows them to play a small 'interactive' mind game with it."
-Gregory Thomas

line

The way in which a line is drawn can evoke different moods or meanings. A composition dealing with right angles at various degrees produces a very "sharp" and potentially dangerous situation, whereas a soft, sensuous line implies a gentle, nonaggressive attitude.

shape

Although we have already discussed the origin of the three distinctive shapes in the introduction, it is important to realize that a square is the most visually stable. Next are the circle and the triangle. Rectangles, both horizontal and vertical, and ellipses are the most visually unstable.

figure ground

Ever see the drawing of a vase that could be two faces as well? This is a good example of figure ground, where positive and negative shapes interact to provide a mental puzzle. Whether it's called ying yang or gestalt, figure ground is a universal technique.

pattern

When dealing with geometric shapes, it is often tempting to continue the thought and create a pattern using elements of the trademark. The example shown above through right illustrates the progression. While sometimes this approach is useful in branding, it often runs the risk of placing the mark in legal jeopardy, since the simplicity of this approach also makes it less unique.

letterform

Using common letterforms but in unique configurations can create a often simple but effective means to trademark development. Traditional typography refers to these as "ligatures" which you will frequently see in old style fonts in the form of "Ffl," "ft."

contrast

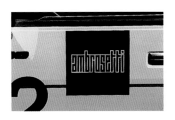

Variations of letterform weight and size also help create a subtle meaning in the wordmark that could not be obtained otherwise. These examples are reminiscent of the skylines as well as the personality of the cities they represent.

image field

A letterform or design can find an environment in a number of different situations. Reversed out, overprinted and more. It is important to realize that the area around the object can define it as well as a literal drawing of it.

perception

Simple linear and geometric forms can convey completely different meanings with the slightest modification. The first figure above makes the square strong and dominant, while the center of the square becomes weak and unanchored. The center figure becomes tranquil with all elements creating harmony. The final figure is the complete opposite of the first figure in that the center elements become strong and aggressive, while the square becomes subordinate.

The Ten Criteria for Development
of a Successful Logo, Symbol or Icon

Whether you're at the beginning of your design career or whether you are internationally recognized in the field of corporate identity, the primary considerations in the creation of a trademark, symbol or icon are the same. Immediate identification, as well as the visual definition of what a company or product is or how it works, are the objectives. Developing a successful symbol requires meeting many different criteria. Listed below is a checklist of ten criteria that must be considered in the creation of a good logo, symbol or icon:

1. Visibility
Will it stand out in its surroundings to provide quick and memorable identification. Seeing how a logotype stands out among the clutter of a metropolitan downtown is a good visual test for many trademarks.

2. Application
How well can the symbol be used in a variety of applications? From the resolution of a video monitor to the heat stamping on a product, it must withstand numerous technical applications.

3. Distinctiveness
Will the application distinguish itself from its competition? It is important to note that many legal decisions are made based on how similar a mark is to its competitor, and many challenges have been won in the courtroom.

4. Simplicity/Universality
Is the symbol's concept easy to identify? As those who have "overworked" a drawing will know, there is a point at which to stop embellishment. On the other hand, a few additional lines in a composition can make the difference in its readability.

And don't forget cultural readability. One must be sensitive to any cultural or religious connotations the mark may convey.

5. Retention
Someone who will identify with a mark must play a small game of mental tennis with it. (The Bank of America's symbol is a good example of this—once a person has read the shape of the letterforms as an eagle, they will never see it any other way.) If a symbol is too easy to read, the viewer will feel no sense of discovery and thus no personal equity with the mark.

6. Color
It is good practice to design everything in black and white first, while keeping in mind the color applications. A good symbol must work in a number of technologies—such as a fax or photocopier—that are unable to display the subtle nuances of some color palettes or blind embossing.

7. Descriptiveness
Does the symbol reveal to some extent the nature of the company or product? A good symbol is one that is able to do this without being an exact literal translation.

8. Timelessness
It was once hoped that a good trademark would last from fifteen to twenty years. Now we are seeing complete turnovers of identity programs within a five-year period. Even so, you still need to be careful not to follow current trends, for they have a limited life expectancy.

9. Modularity
Will the potential mark be adaptable to numerous applications? We have seen the best marks diluted in their presentation by the way the support typography or other graphic elements are handled. All the elements must work together to form a single voice.

10. Equity
The age, use and recognition of a mark is also a primary consideration in its development. Knowing when and what to redesign are important considerations for the designer. If one were to be approached to redesign the Coca-Cola script, it would be hard to replace the value the current mark retains.

Some have different opinions about the value of equity. For instance, in a dramatic move within the last year, Steve Jobs of Apple decided to change the famous Apple symbol from multicolored to a solid one-color mark. His rationale was that the old symbol reflected too much on the early days of Apple and not where the company was headed. In challenging this move, I would propose that it was those early days of invention by two young men in a garage that should be kept alive.

The Three Categories
of Logos, Symbols and Icons

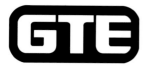

All marks fall under one of three categories:

1. Descriptive Marks

A descriptive mark uses visual imagery relating to the clients product or service. By manipulating the letterforms of an "i" and a "p" (left), Integrated Paper Corporation demonstrates their area of activity and defines the initials of the company.

2. Symbolic Marks

A symbolic mark takes the descriptive mark one step further, literally incorporating a figurative element, such as the former Bank of America "bird in flight" logo (left), in order to communicate the intangible or abstract—the client's positioning, mission, ethics, etc.

3. Typographic Marks

Sometimes letterforms are used as a starting point. A typographic approach must include some graphic organization or addition to its content that will enhance it. The letterforms for GTE (left) fall within this category.

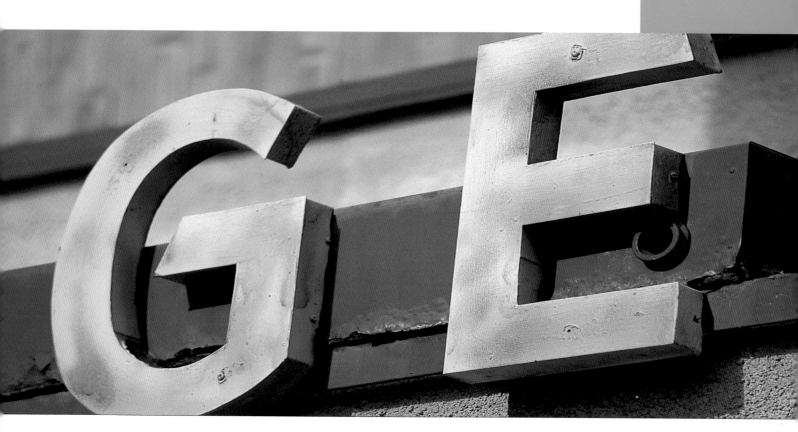

CASE STUDIES

What moved young designers in Germany to this unconventional solution?

A pulsing moiré pattern represents the first world exhibition of the new millennium.

p. 28

A company expands and their logo shrinks?

Zoom in on this solution.

p. 34

What is the difference between a playful mark and a parent mark?

Explore the clever concept behind the logo for the Pittsburgh Children's Museum.

p. 38

Can a logo sound like music?

See the development of an identity for an interactive music and and performing arts museum.

p. 42

What's the driving force behind this flexible mark?

Getting the most mileage and flexibility from a simple solution.

p. 44

How does the past influence today's logos?

Find out how sound waves of the 1950s gave shape to a logo for a unique recording studio.

p. 50

Is it possible to represent two conflicting themes in one logo?

A web company's quest for a scientific look with a human quality led to mathematical equations.

p. 52

2-LANE *media*

How do you compress the universe into one logo?

A visual theme of stellar constellations is advanced into a mark for a new online service.

p. 56

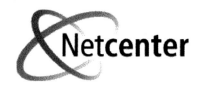 Netcenter

What is aesthetic symmetry?

This mark achieves the perfect balance. Learn about this designer's intention.

p. 58

Design means more than what meets the eye.

For MetaDesign, this statement rings true. Explore their extensive developments for Audi's new corporate design.

p. 60

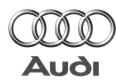
Audi

What is Sony's latest invention?

An allusion to old Broadway fonts and urban culture of the 1930s and 1940s is the focus of this new design.

p. 66

METREON
A SONY ENTERTAINMENT CENTER

A logo that actually grows.

Learn how the employment of visual metaphors can be a successful design method.

p. 68

Where is the Swoosh?

nike

Read about Nike's latest brand usage system and the retrofitting of a historical wordmark.

p. 70

"The eye and ear of the world."

This statement led to an excellent design vision.

p. 76

Does logo design end with the application to the stationery?

This identity helps unify several facilities for a new symphony center.

p. 80

Why five instead of four holes?

Find out how a giant button in the streets of New York symbolizes so much.

p. 84

When does international suitability play a role in logo design?

Americans developed this identity for a Brazilian bank. Learn how cultural differences influence a design process.

p. 86

Can a single dot make all the difference?

Sometimes the simplest idea is the strongest solution.

p. 90

How many different symbols do you see in this logo?

Eight symbols are elegantly unified into a single mark. Decipher this brilliant concept.

p. 92

Unifying four unique airports on schedule.

Discover the criteria behind the fusing identity for Los Angeles's airports.

p. 96

What is the role of the customer in design?

The idea of "understanding and anticipating customer needs" furthered this logo's vision.

p. 100

Why does this logo need its privacy?

Customer perceptions related to security and confidentiality played a decisive role in the design of this excellent mark.

p. 104

How to design a logo with no name.

Tight time constraints called for identity explorations while the name was still in development.

p. 108

Find out how an eagle changed to stripes.

A large merger between two important banks meant a major repositioning.

p. 110

What is a virtual identity?

For Texas Instruments, a class at Carnegie Mellon University predicts the future of identities as hyper real.

p. 116

Is the pen mightier than the microchip?

Fresh ideas don't always originate from the computer. Get inspired by ArtCenter College of Design student Jean Lee's method.

p. 124

VILLE DE GENÈVE

W.C.

FLEXIBLE IDENTITIES

DMD

MPeg

TIRIS

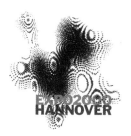

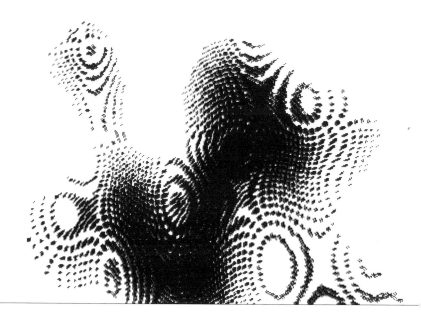

Expo 2000 Hannover

Qwer

Hannover, Germany

Nine renowned German designers, including Erik Spiekermann of MetaDesign, Uwe Loesch and Gunter Rambow, were elected to nominate other young, outstanding and unknown designers and groups to participate in a logo design competition.

The Project

Expo 2000, the first world exhibition of the new millennium, is a global forum for innovative solutions and futuristic strategies that integrate man, nature and technology into successful and responsible industry profit. Expo 2000 will take place in Hannover, Germany, from June through October of 2000. Thematically, the focus will be on the relationship between man, nature and technology. Special consideration will be given to the central question of humanity at the onset of the twenty-first century.

In 1994, Professor Egon Chemaitis, a consultant at the management department of Expo 2000, conceived of a unique competition for the Expo 2000 logo: Nine renowned German designers, including Erik Spiekermann of MetaDesign, Uwe Loesch and Gunter Rambow, were invited to nominate other young, outstanding and still unknown designers and groups to participate in a logo design competition.

This progressive concept reflects the fundamental goal of the world exhibition: to showcase futuristic and visionary perspectives, approaches and strategies for the next millennium.

The Briefing

The competing designers, including the German studio Qwer, were asked to develop a logo that comprises and mediates the complex global theme of the Expo 2000. The logo had to:

- speak to the theme "Man, Nature and

Technology," the futuristic keynote of Expo 2000;
- be a distinguishable mark;
- be easily recognizable;
- have a simple yet sophisticated shape;
- be successfully applicable in various media (print, animation and Web design);
- be able to be reduced or enlarged in size ;
- be able to be printed in either a multitude of colors or one color;
- stand alone as well as with the text "Expo 2000 Hannover."

The logo was to be used for licensing, merchandising and sponsoring, and the targeted market was mankind in general.

The Process

Since its premiere in London in 1851, the World Expo has taken place irregularly in different cities around the world. Qwer's research of previous Expo logos helped define how the task should be approached: most of the former Expo identities reflected variations of the terrestrial globe—a commonly used symbol in corporate identity that, although metaphorically rich, was no longer distinctive, suffering from overusage in the imagery of travel agencies and cargo and communication industries.

The Qwer designers, Iris Utikal and Michael Gais, were captivated by the possibility of abstract characterizations of movement, process and development, qualities the exhibition promises to

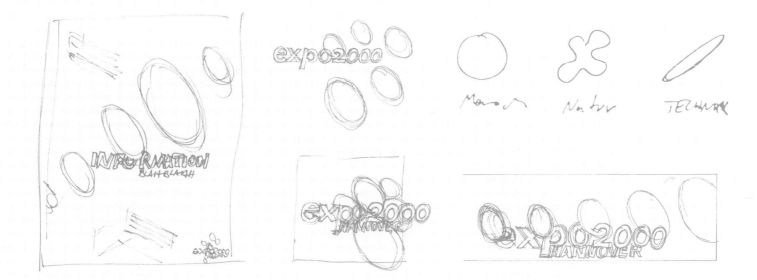

mediate to its visitors. They approached the motto "man–nature–technology" with an emphasis on man's capacity to comprehend progress and to adapt to the nonlinear complexity of events. The motto's broad scope challenged the designers' conceptual and creative skills to their limits.

The Solution

The final logo is a moiré pattern that changes its structure and color depending on the application.

The international jury, composed of renowned graphic designers such as Katherine McCoy (USA), Gert Dumbar (The Netherlands), Ruedi Baur (France), David Hillman (United Kingdom), Dan Reisinger (Israel) and D. Pirous (Indonesia), described their impressions of the logo as follows: "On one hand it is an organic biological structure and on the other it is a symbol for rapid technological change...it is a dynamic shape that stands in contrast to the static typography. It is like a phenomenon that cannot be captured...it is a continuous metamorphosis..." Qwer explains, "The logo is an impulse in constant movement. It is like a field of force that sends energy; the structural shape leaves the observer with a broad interpretation of a unique picture that can be both organic and technical in nature. Furthermore, the logo is the mirror of dynamic developments and invites our participation in the future."

Posed on top of the words "Expo 2000 Hannover"—which function as the stable basis—the structure is analogous to the vital signs or pulse of the exhibition. It is a multifaceted logo for the many cultures involved in Expo 2000. Qwer's central criteria for the mark was to address the rapid developments in media and technology and establish a dynamic identity that reflects these processes while remaining a sign of its times.

After Qwer's logo was chosen by the jury for the World Expo:

- the readability of the logotype had to be optimized;
- the small versions of the logo sizes had to be developed, and the color combination possibilities had to be improved;
- the animated logo sequences had to be realized.

The logo's flexibility is represented best through motion graphics, in computer-animated films, on information terminals and the Internet. In print media and all other "significant media" such as public transportation, stickers and flags, the dynamics of the constantly transforming identity are indicated by the usage of different colors and structures.

The color coding played an important role. Since the purpose of the logo is to reach a multicultural and multitheistic audience, different color interpretations were considered. The variety of shades and tones for the mark as well as its background is a major advantage for the different countries, organizations and companies that use the logo for promotional purposes. They can, within limits and

World Expo 88
Brisbane Australia
April – October

58

CENTURY
21
EXPOSITION

LISBOA
EXPO'98

EXP⦿'92
SEVILLA

EXPO 2005

Exfo'95

according to their customary preferences, choose
their own color schemes.

The high design quality of the "fluid identity"
allows it to adapt to different media while still
maintaining the desired communication.

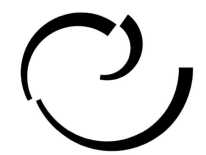

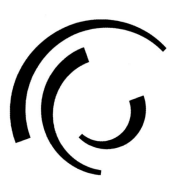

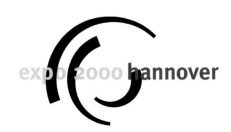

The final logo, a moiré pattern that changes its shape and structure depending on the application.

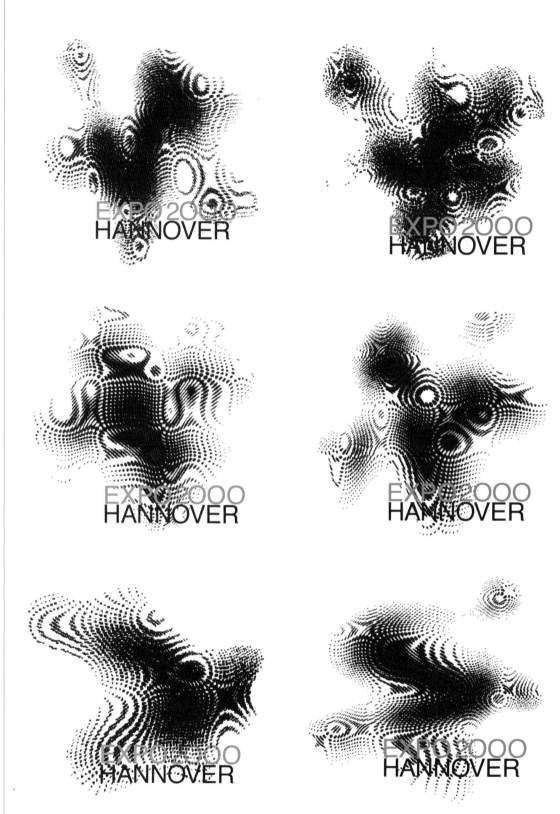

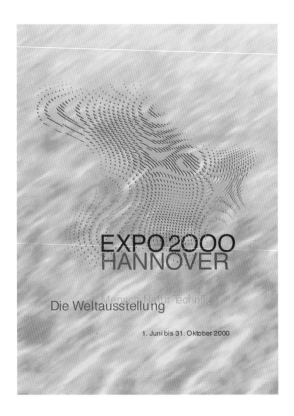

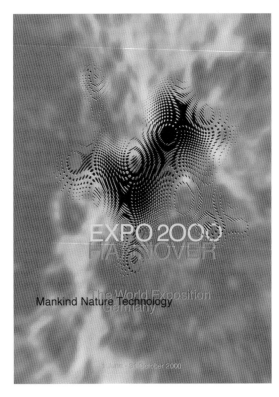

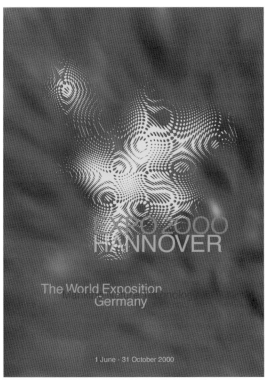

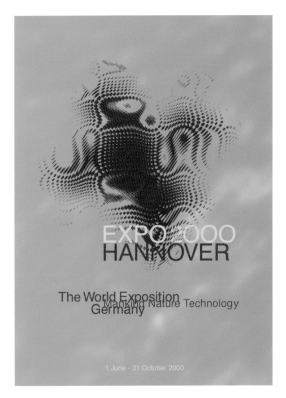

A series of posters in vibrant colors introducing the "malleable" identity— the figure seems to, like plasmatic tissue, be in constant movement without losing its consistent "corporate" feel.

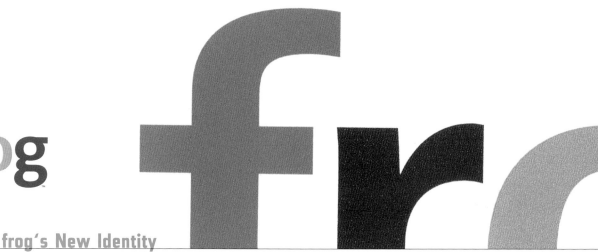

frog's New Identity

frog
Silicon Valley, San Francisco, Austin,
New York, Ann Arbor, Düsseldorf, Altensteig

The Project

frog Inc., a global, award-winning product design company, is also among the world's most renowned consultancies. Founded in 1969 by the German designer Hartmut Esslinger, frog is based in Silicon Valley, California.

Presently, their work includes three distinct yet mutually reinforcing design areas: eBranding, eMedia, and eProduct. These disciplines are catalyzed in a unifying strategy for transforming business visions. It is called Creative Convergence for eConomy.

frog approaches design solutions with Louis Sullivan's famous adage "form follows function" and with their own axiom, "form follows emotion," frog's functional products speak a personal language and are, thus, user-friendly. The constantly expanding corporation is now operating in three countries. Recently two new offices in San Francisco and New York were opened.

The original logotype "frogdesign" has existed for thirty years, always appearing in conjunction with a simple icon, which is frog's amphibious mascot "Friedolin." By 1997, an appropriate representation of the company's advanced multidisciplinary design practice was needed. "frogdesign became too big for its name," says the design consultancy.

The Briefing

frog charged its own in-house graphic design team (headed by Gregory Hom) with the task of creating a new identity that reflected the full breadth of services offered by the large, multidisciplinary corporation.

The Process

frog's diversification called for a repositioning of the brand. Early proposals included photo and typography combinations evoking the concepts of growth and flexibility. These directions, however, seemed too frivolous and failed to include frog's functional approach.

A comprehensive solution expressing the evolution from an exclusive product design heritage to a full-service corporation was required. The words "frogdesign" were to be changed. According to frog management, the word "design" was misinterpreted by consumers and clients, and hence was limiting. "Designing is often perceived as an exclusively cosmetic exercise, such as coloring and shaping, whereas design also means analytical problem solving," says Gregory Hom. Since frog offers both business and aesthetic solutions, the word "design" was omitted from the lettermark, leaving simply "frog." The decision for the final design fell once again on the lettermark. Different possibilities for intricate type treatments were subsequently explored.

frogdesign. **frogdesign.** **frog**design.

frogbrand. **fro**gbrand. **frog**brand.

frogmedia. **frog**media. **frog**media.

frogproduct. **frog**product. **frog**product.

The design process took two months. The new logo was introduced in the spring of 1998.

The Solution
The solution is a quadritonal logotype with each letter in a different color. The green symbolizes frog's "amphibic" heritage, whereas the other three shades represent the palette from which all frog's corporate identity elements are now mixed. The colors also signify a more open and flexible interpretation of their identity as a whole. And because frog views color as a very subjective, personal issue, every employee chooses the tones for his or her business card. This is a statement of frog's holistic understanding of communication in corporate design, where each employee gets actively involved in the process.

The simplicity of the new "frog" wordmark directs attention to its detail; different sans serif font styles were explored and manipulated. The typeface used in the new logo is a modified font based on the Frutiger family.

"Friedolin," frog's mascot, no longer appears prominently in frog's advertisements, or attached to the logo itself. "Rather than being saddled with the stuffy responsibility associated with an international corporate identity, Friedolin will be allowed to play a new and mysterious role within the CI system," explains designer Gregory Hom. As an addition to

the new logo, frog published a brochure entitled "Change is fun" introducing the new identity to their clients. The brochure includes a brief history of the corporation translated into four languages. It shows their work strategy, and gives an overview of the possibilities of the new color scheme.

Above
From left to right: Typographical explorations and modifications of sans serif fonts based on the Frutiger.

Color explorations of the former "frogdesign" name, integrating frog's three design disciplines.

Left
frog's former logo: The mark was composed of the icon and the logotype. The mark below shows an early phase of the new design process: The name was shortened to frog. But this particular mark still integrates the mascot.

frog frog

The new "frog" logo, reduced to a wordmark.

frog

Right and above
A test of the positive/negative qualities of the typeface.

frog

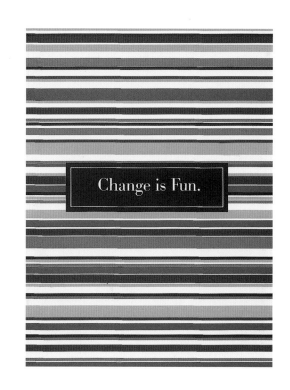

Change is Fun.

Far right
frog's corporate brochure entitled "Change is fun."

A scrutiny of various typefaces for the new mark focusing in particular on the letter "g."

frog frog frog frog frog

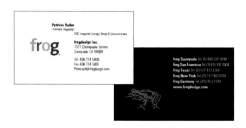

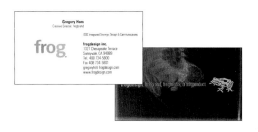

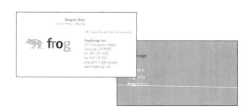

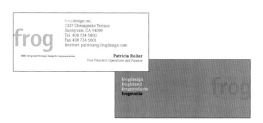

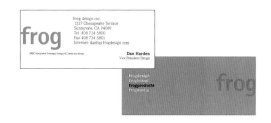

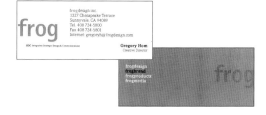

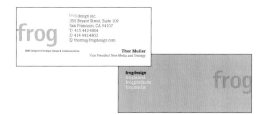

It's a frog thing.

Left

The application of the new
identity on the business
card. Different explorations
of color, composition, size
and theme on both sides of
the card.

Here the concept of
introducing a multiple
color scheme is success-
fully integrated into a
slogan without detracting
from its consistency.

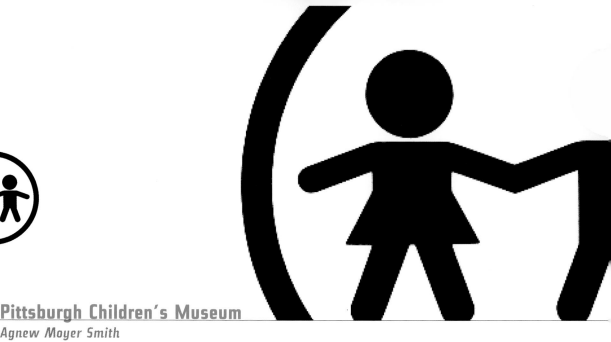

Pittsburgh Children's Museum

Agnew Moyer Smith
Pittsburgh, Pennsylvania

The intention was to make the logo look more playful within the circle, portraying situations that could take place in a child's playground and then abstracting them to a few major poses.

The Project

The Pittsburgh Children's Museum, which opened in 1983, was created to serve the needs of its community. In conjunction with community groups and schools, its mission is to engage the lives of children and families of diverse backgrounds in activities that foster creativity, learning and discovery. The museum utilizes artifacts, hands-on exhibits, performance art and story-telling activities to help children better understand art, themselves, their cultures and the world around them.

The Briefing

The Pittsburgh Children's Museum presented Agnew Moyer Smith with a basic design direction and graphic theme: a circle surrounding a boy/girl pictogram. The challenge was to transform the static boy/girl elements into a proportional, dynamic and playful mark sympathetic to both children and their parents and representative of the interactive museum.

The Process

Because of these design restrictions, the work really entailed reorganizing and restructuring the constant elements. The intention was to make the logo more playful within the circle and portray situations that might take place in a playground. In a final step, these situations were simplified and abstracted. A few typically childish or playful actions emerged.

The Solution

The solution is not a single logo, but a basic trademark and a series of "animated" variations that convey the enjoyment associated with the activities at the Pittsburgh Children's Museum. The "animated" sketches are divided into a "parent mark" and a "playful mark." The marks are highly compatible and flexible to intended usage. The "parent mark" is primarily a fixed mark that appears as a static sign. It emerges on virtually all printed material, whereas the nonstatic, "playful mark" has a secondary role: it can be added or left out, depending on the needs of the museum. The "parent mark" can also appear in a smaller version together with the logo name, "Pittsburgh Children's Museum"; in this case the playful mark is enlarged.

Most publications and print materials feature the animated marks in a variety of colors. The "parent mark" utilizes a solid circle, whereas the "playful mark" employs line screen concentric circles that avoid halftone screens and make the line look gray (lighter than the "parent mark"). This effect calls attention to the childlike figures. Although the concept approach is intended to make the identity as playful as possible, the use of the "parent mark" and the "playful mark" with the museum's name allows for a clear corporate recognition.

The logo variations are printed on ads, brochures, banners and exhibit signage.

"Parent mark is always solid circle. Parent mark always appears a small signature on all items.

the concentric circle screen was a clever production

Playful marks are always made of line screen of concentric circles which makes the circle appear a gray lighter than parent

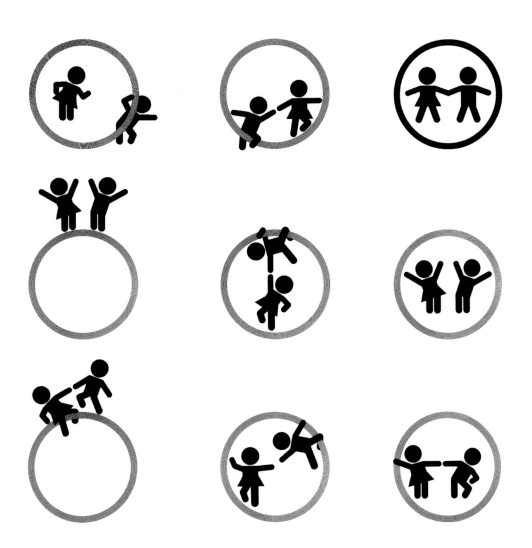

The sketches explain the basic visual difference between the "parent mark" and the "playful mark."

The vibrant color scheme of the mark supports the fun image the Pittsburgh Children's Museum intends to convey.

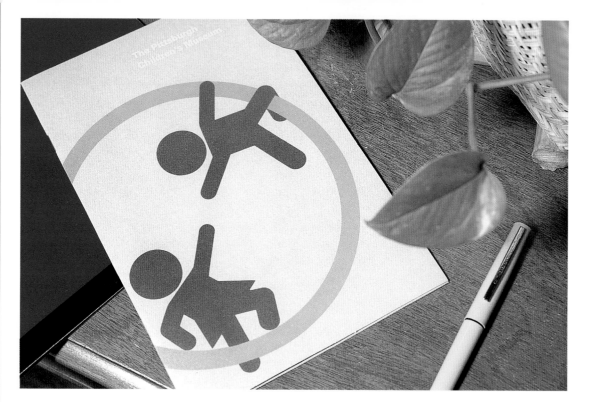

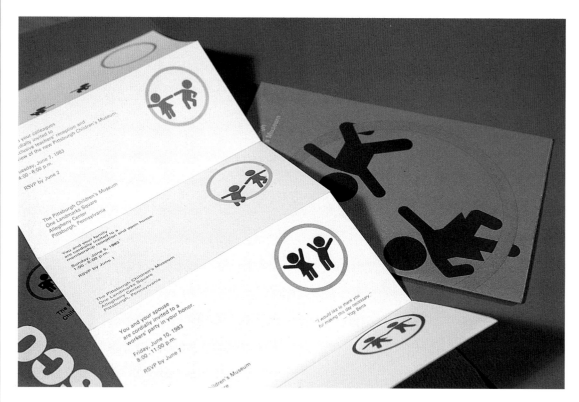

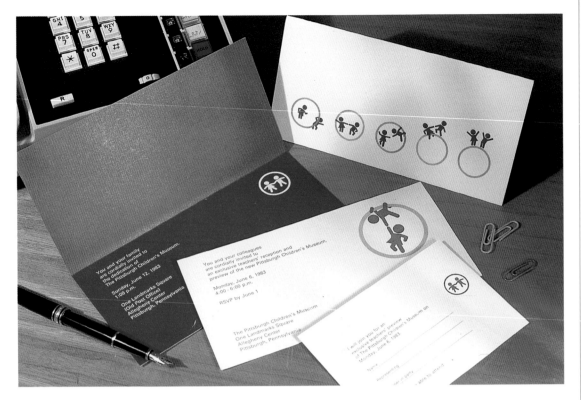

The plan to introduce the "parent mark" and "playful mark" allows for versatile, flexible and humorous layouts for a variety of stationery.

EMP

The Leonhardt Group
Seattle, Washington

The Project
The Experience Music Project is an interactive music and performing arts museum celebrating creativity and innovation in American popular music and culture, with an emphasis on northwestern musicians and rock 'n' roll. Designed by architect Frank Gehry, EMP opened in Seattle in 2000.

Through exhibits and educational programs, Experience Music Project hopes to encourage visitors to listen, learn and participate in making music. The museum hopes to inspire individuals to discover their own creative potential without relying merely on a display of static exhibits.

The Briefing
The Leonhardt Group was commissioned to design a logo to express the unique characteristics of the museum, especially creativity and interaction, for all ages.

The Process
Initially three different directions were developed. The first direction focused on the concept of a fluid identity: the shape of the mark would change with each application, a metaphor for the subjective interpretation or individual perception of music. The second direction explored aesthetics common to rock posters. The final idea focused on the question of how to visualize creativity, which is a core attribute of the museum.

The three logo solutions were, as part of the research process, directly applied to different environmental scenarios: posters featuring the logos were installed in cafes and bus stops, and printed on T-shirts and worn by people on the streets. This phase was documented in order to determine in which contexts each logo would work best. One basic concept proved to be especially important: a logo that continuously changes according to its reception by the targeted audience.

The development of the logo took two months, with an additional six months required for the final application. The mark appears on printed media, museum publications, electronic media and as a projection onto the museum's facade.

The Solution
The fluid identity was chosen because of its strong conceptual representation of the museum. "Everybody experiences music in his or her own way. Two people can listen to the same piece of music and have completely different interpretations of what they just heard and felt. That's the beauty and power of music. It can say everything and yet nothing to anyone and everyone. Inherently, music and creativity are interpretative. EMP's brand reflects this dynamic," explains The Leonhardt Group in their concept brochure.

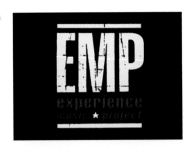

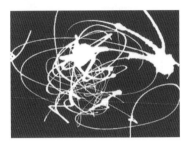
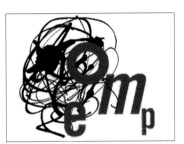

1–3

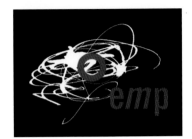

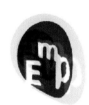
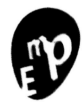

7

8

10

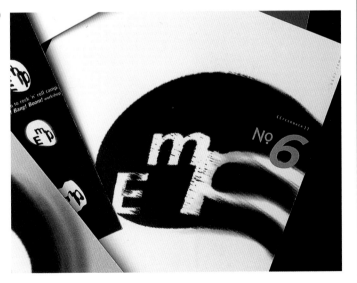

9

1–3
Direction no. 2: Is there a typical pattern that identifies and reappears on any rock poster? The Leonhardt Group researched this idea— the conclusion was the logo shown above.

4–6
Direction no. 3: How does one visualize creativity? Music has no shape and no form—creativity has no defined shape nor form. The ring is a strong symbol that defines or focuses— the ring captures different kinds of creativity.

7–10
Direction no. 1 and final solution: With every new application the logo appears in new bulbous forms—it is as dynamic as music itself. "With this direction we leave interpretation to the individuals. They decide for themselves what EMP's brand means. Unorthodox, fluid, rhythmic, nonconformist, mystifying, cool, offensive, irreverent, ugly, refreshing....The exercise of performing a perception is an exercise in creativity itself. EMP is a place that challenges, taps into, and releases creativity. So, too, should its brand."
—The Leonhardt Group

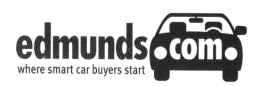

where smart car buyers start

Edmunds.com

Gregory Thomas Associates (GTA)

Santa Monica, California

Research
and analysis
made clear
that in order to be
competitive and
progressive,
the new logo design
had to emphasize
Edmunds.com's
electronic habitat,
the Internet.

The Project

Edmunds.com is the leading free third-party automotive resource on the Web. The company was founded in 1966 as Edmund's Publication Corporation, which publishes magazines, providing consumers with comprehensive information on key aspects surrounding new and used cars and trucks. Since 1994, Edmunds.com has presented a well organized index of numerous hypertext links including prices, ratings, buy/lease advice, reviews, safety reports, auto products, CD-ROM's, books and contests on the Internet. Additionally, the visitor can benefit from a community chat room and a news section.

More than 1.3 million people visit Edmunds.com monthly, around thirty-two times the amount of their print readership. Consequently, Edmunds.com has focused on expanding and improving its web site. This process required a name transition from Edmund's to Edmunds.com in 1999.

The Briefing

The company was in need of a revised logo and CI system as a result of the new changes. Edmunds.com commissioned Gregory Thomas Associates to either rework the old logo, or to design an entirely new direction. Edmunds.com specified an identity that would:

- be durable and timeless;
- have an instant recognition to become the "Kleenex" of auto internet sites;

- become a strong brand on the level of a Nike or a McDonald's;
- develop equity at a quick pace.

The Process

GTA's starting point was the careful review of the old Edmund's script logo. Its value is substantial since it has brought success to the company for over thirty years. Its classic 1950s font style not only points to the company's heritage, but embodies the Detroit auto industry's characteristics and reflects the company's California origin. Moreover, today's constant style revivals add a certain coolness to the sleek mid-century logo. These were convincing motivations for retaining the basic characteristics of the original logo with only subtle adjustments to the new name, Edmunds.com, by improving its readability.

After subsequent analysis and comparison to different auto industry entities, however, these initial directions were discarded. It became clear that in

1

Edmund's

Edmunds.com

1
The original Edmund's logo and an initial study with '.com' added using the original logo's typographic style.

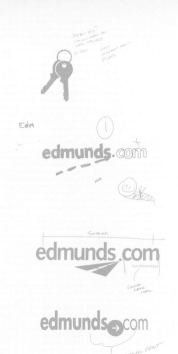

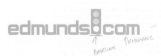

order to be competitive and progressive, the new logo design had to emphasize Edmunds.com's new electronic habitat, the Internet.

Because Edmunds.com deals with numerous aspects within the automobile industry, including a myriad of transportation issues, the concept was to create an interchangeable, flexible mark. Three primary categories—sedan, SUV and sports car—were developed. GTA's plan was to integrate the Web application into the logo. Since the new name "Edmunds.com" made the dot an integral part of the logo, GTA researched ideas related to both transportation and dots. The dot became a wheel, a traffic signal, etc. Most of these ideas were unfortunately too literal and didn't fulfill some broader implications that the client had envisioned. Invocative metaphors for notions and concepts such as positive, forward thinking and experimental, coupled with the idea of an interchangeable mark, were explored. These included "blazing a path," "lighting the way," etc. The idea of using a car's headlights as the "dot" (from ".com") was derived from this phase. Another client meeting approved the idea of incorporating three different car style images (sedan, SUV, sports car) into the logo.

An additional tag line necessary to help define the brand was also discussed. GTA searched the Los Angeles Times auto section for words capable of defining the brand. The words were mixed and

2–3

edmunds!com
edmunds!com
edmunds!com
edmunds!com
edmunds!com
edmunds!com

edmunds!com
edmunds!com
edmunds!com
edmunds!com

4

edmunds!com
infomotive

Above
One idea used keys as metaphors (top left): Edmunds.com as the key service to the automotive industry. It was discarded because it could lead the consumer to think of Edmunds.com as a car purchasing service, not as a car information service. Other initial logo concepts used the theme of traffic by employing street signs, traffic lights, abstractions of highways and various automotive subjects, such as the wheel.

2–4
Utilizing an exclamation mark was a potential candidate. It intended to invoke surprise, even joy and wonder, as traits that Edmunds.com intends to inspire. This approach, however, was dismissed because it was too abstract and neglected the immediacy of Edmund.com's business.

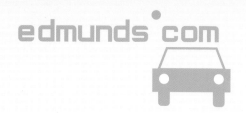

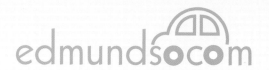

Right

Early explorations
incorporated an
abstraction of the
car into the logo.

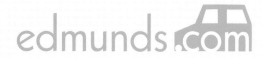

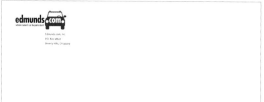

Right

The placement of the
final logo on stationary
depends on the use.
For business cards
and envelopes the logo
position is oriented to
the left, whereas on the
letterhead, it is placed
on the top right.

matched with the beginnings of some and the
endings of others. Numerous lists were created
that ranged from frivolous and random to serious
solutions. Finally, the choice was narrowed to two
taglines — "consumer driven" and "where smart
car buyers start." Focus groups conducted by Suisse
Miller, Edmunds.com's advertising agency, showed
that consumers related to the specific definition of
the company's consumer benefit rather than the more
abstract phrase representing the company philosophy.
"Where smart car buyers start" became the tagline.

The Solution

The final mark depicts the new name incorporating
a sedan (or sports car or SUV) and is accompanied
by a tag line. Utilizing these three interchangeable
logos best embodies the Edmunds.com philosophy.
The diverse logo not only shows the wide spectrum
of reviews available from Edmunds.com, but indi-
cates the wide range of opinions that Edmunds.com
offers to its customers. Also, the use of three versions
of the logo stands for the diversity of the customer base
that is drawn to the Edmunds.com web site.

Although the placement of the logo on all individual
collateral (e.g. business cards) is consistent, each
Edmunds.com employee chooses the logo that match-
es his or her individual personality. On envelopes and
letterheads for the branch offices, one logo is chosen
to represent the group personality of the entire office.

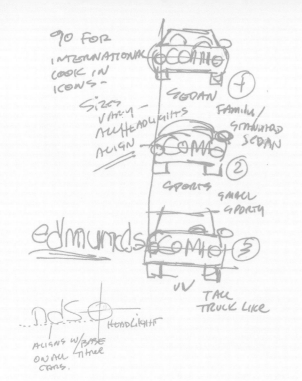

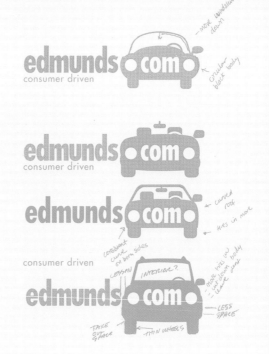

Left
Final adjustments to
the logo worked out
the differences between
the three car styles.

5–8
A palette of three
colors was developed
to be interchangeable
between the three logos.
The colors sports-car red,
royal blue and British
racing green are reminis-
cent of auto paint and
traffic sign colors and
subtly reinforce the
automotive nature
of Edmunds.com.

9–11
The application of each
of the three logos depends
on the subject matter on
which it is to be presented.
For instance, the Web page
for sedan information
would show the sedan logo.

5–8

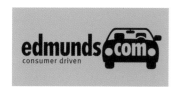

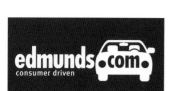

9–11

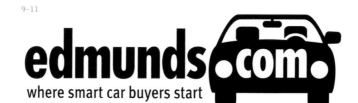

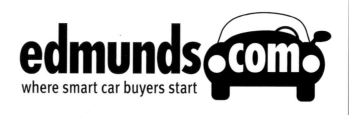

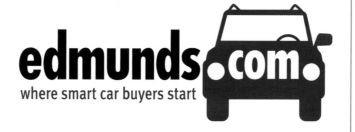

LOGOTYPES

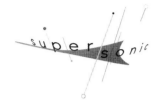

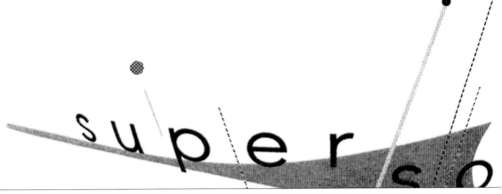

Supersonic

Skolos Wedell
Charlestown, Massachusetts

From the briefing, it was clear that the logo should create a feeling of sound waves traveling, resonating and expanding toward the audience, and create a hip and retro feeling without being too trendy.

The Project
Supersonic is a new music studio owned by a musician with a unique vision: his concept is to use vintage sound equipment from the 1950s and 1960s. There is no digital technology at Supersonic, only analog.

The Briefing
The objective was to convey a music production company with vintage technology. Supersonic's founder was directly involved in the design process and made clear in the briefing that the logo should portray resonating sound waves that expand toward the viewer. The mark was also meant to evoke a hip, retro feeling without being too trendy. The founder asked for an identity that would convey the studio's remarkable qualities to an audience of music professionals.

Because of a limited budget, only two colors were possible for the final design.

The Process
Initial research focused on typefaces, signage, boomerang or finned shapes and colors typical of the midcentury. E. Lokelani Lum-King and Melissa Gordon of Skolos Wedell focused on the usage of dot pattern (halftone patterns) and type treatments to convey the movement of sound, and developed shapes that would suggest analog music recording. The next step was to explore the letter "s" or similar forms, as representative of the spinning tape,

expanding through its pattern. Gradation and letterspacing emphasize movement in the word "sonic."

The focus remained solely on the name as a single contemporary and whimsical unit, with retro undertones that stand out from others in the field. Through the use of a halo created by the dot pattern, an impressive glowing effect was achieved.

Another design phase consisted of several variations related to the initial idea, using the dot pattern to suggest sound waves. Manipulation of letterforms created the effect of outwardly expanding sound waves—these are the oval shapes that the final type formation came from. The design process took six months and 180 hours of work.

The Solution
The final logo depicts various elements of music, including sound bites and waves. The distortion of type shows the elasticity of music and attempts to provide grounding for the dancing sound bites. The logo communicates kinetic energy and the personality and character of Supersonic's owner, which are crucial to the business.

The final variation of the distorted type was the closest to the initial proposal, with split text and other graphic elements such as a ruler and a circle. The logo appears on stationery and newspaper ads; it is an economical solution that also works well in black and white.

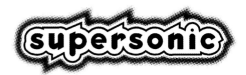

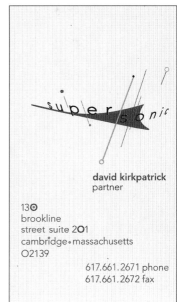

david kirkpatrick
partner

13⊙
brookline
street suite 2O1
cambridge•massachusetts
O2139

617.661.2671 phone
617.661.2672 fax

"The logo represents the elements of sound, sound bites, music...it shows that Dean (the owner of Supersonic) is creative, hip and a little bit out of this planet. The shape evokes movement as if you were saying the word 'supersonic.' It carries your eye around the word, through the music bars as you read the word, and then brings it back to the left because of the natural gravitational pull."—Melissa Gordon

Left
The application of the final logo onto stationery.

2-LANE *media*

Two-Lane Media
Vrontikis Design Office
Los Angeles, California

Vrontikis' aim for the identity was clear: she wanted to stress Two-Lane Media's advanced, strategic method in web design which successfully balances information flow with visually attractive design.

The Project
Two-Lane Media, founded in 1992 by the Lane brothers, is one of Los Angeles's pioneers in exclusive Web and CD-ROM design as well as concept development. Two-Lane's first logo combined the images of the "information highway" and the brother's family name in a depiction of a road with two lanes. In 1992, Two-Lane Media opened an office in Malaysia and needed a new identity that would reflect their global outreach.

The Briefing
Two-Lane Media commissioned Vrontikis Design Office to design a mark that would express the company's innovation, creativity and functional qualities. The client told principal Petrula Vrontikis that the logo should envelop the company, lend a sophisticated quality to the company's image, and speak to the future and to the company's global clientele.

The Process
Vrontikis' aim for the identity was clear: she wanted to stress Two-Lane Media's advanced, strategic method in Web design, which successfully balances information flow with visually attractive design. The logo needed a somewhat scientific look. Also, it needed to have a human touch, since another unique quality of Two-Lane Media is their service-intensive relationship with their clients.

Early proposals included numeric and alphabetical hybrids for "Two-Lane." The numeral "2" with the acronym "LM" was proposed as a concise, memorable solution.

The portrayal of strategic design as a mathematical formula was attractive because it would imply an equation for success. Eclipses of various sizes and shapes were also explored as a metaphor for global innovation and proved to be an effective and evocative design element.

The design process took five to six weeks, including three meetings for design presentations and two more for the refinement and establishment of the final design.

The Solution
The new identity for Two-Lane Media has a multi-faceted global and visionary look achieved through the usage of mixed typefaces, line weights, sizes and styles. The composition of the typography together with the two geometric elements, the circle and the eclipse, adds a dimension. The circle is an abstraction for globalization and the opened eclipse stands for what the future might bring.

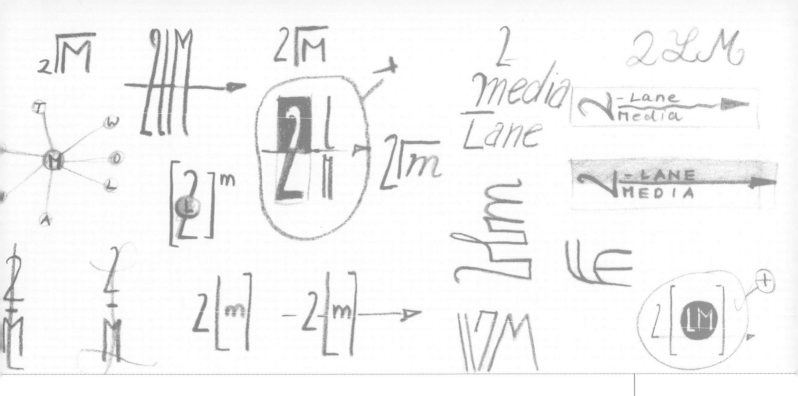

2 [LM]

TWO | LANE • media

2

two-lane media

2

m
2-LANE MEDIA

Portraying mathematical formulas, Vrontikis's logo ideations stressed the client's functional and structural approach to Web design. This concept became the most promising direction. The equations were subsequently simplified, leaving the eclipse as algebraic metaphorical element.

2 [LM]

two-lane media

2-lane) *media*

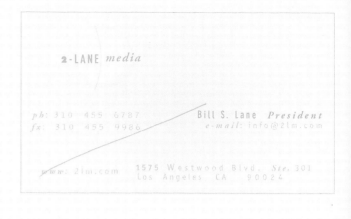

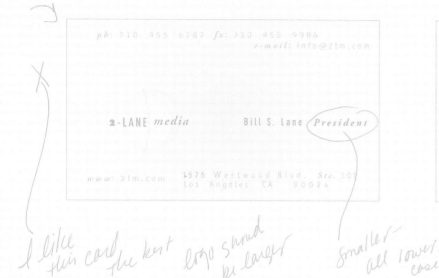

I like this card the best. The logo should be larger.

smaller — all lower case

The second design phase: composition and color refinements.

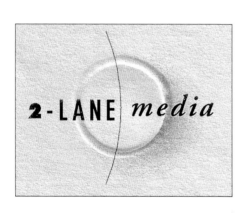

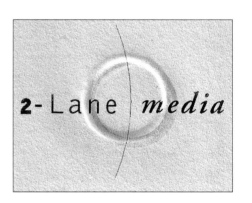

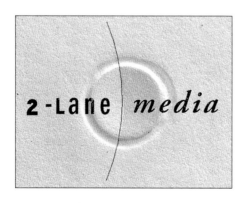

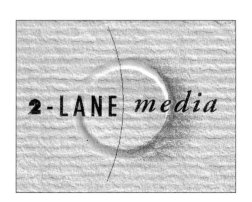

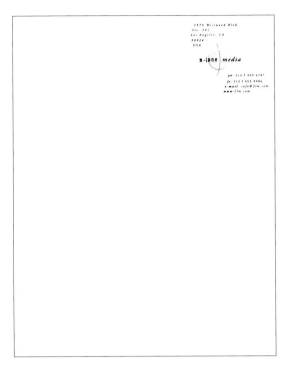

The final design applied to the stationery.

2-LANE *media*

1575 Westwood Blvd. *Ste.* 301
Los Angeles CA 90024 U.S.A.

ph: 310 473 3706 *x* 2238 *fx*: 310 473 6736
e-mail: jpajion@2lm.com
pgr: 1 800 MCI PAGE
#1743285

2-LANE *media* Jonathan Pajion
executive vice president
marketing

www: 2lm.com 1575 Westwood Blvd. *suite* 301
Los Angeles CA 90024 U.S.A.

Netcenter

Netscape/MetaDesign San Francisco
San Francisco, California

The Project

Netcenter is an online portal offered by the San Francisco-based Netscape, America's leading Internet browser. Netcenter consists of a search engine, E-mail service, software distribution, content areas and a Web directory. Its purpose is to provide business professionals with a single integrated Web site with access to superior information services through membership. The design process for Netcenter's logo started at Netscape's in-house design office. Considerations of future scenarios for the service were hypothesized and reviewed. Because of the potential for Netcenter becoming an independent or subsidiary of Netscape, two directions were needed: one in which the design was tied to the master brand and one that could stand alone.

The Briefing

Netscape presented MetaDesign with the following six specific directions for graphic exploration:

- the Netscape logo in conjunction with a unique Netcenter logo;

- a variation of the present Netscape logo;

- the Netscape logo in conjunction with other unique elements;

- a stand-alone Netcenter logo developed as a typographic solution;

- a unique Netcenter logo;

- a stand-alone Netcenter logo in conjunction with the Netcenter name.

Additionally, MetaDesign was given a major visual theme including constellations, the "big sky" and navigation, where small and fast-moving atoms play a major role.

The Process

The initial design phase was limited to the first three days of the project. MetaDesign explored as many preliminary ideas as possible in the form of rough sketches. After a review of these explorations, several selections were chosen by the client for refinement. Approximately ten days before the launch of the new service and following a second presentation, the choices were further narrowed down to two areas: a unique mark together with a type treatment and a stand-alone type treatment.

Pleased with the quality of these results and MetaDesign's ability to work creatively within the parameters, Netscape extended the schedule for the logo an additional two weeks. The developmental cycle, however, remained extremely tight.

The Solution

The final logo design was chosen on the basis of its synergy with existing design themes and the overall Netscape identity. Its abstract depiction of neutrons and electrons, or orbiting celestial bodies, symbolizes the powerful and advanced technology behind the service. The mark's stylized elliptical shapes symbolize speed and continuity. The logo appears primarily as a virtual image in electronic media.

18–23
The final direction:
A unique Netcenter logo
with type treatment—color,
stroke and compositional
refinements of the ellipse.

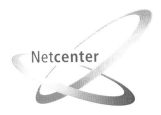

1–4
Left two:
Explorations on the
Netscape logo in
conjunction with a
unique Netcenter logo.

Right two:
The Netcenter logo
as a variation of the
Netscape logo.

5–9
The Netcenter identity
as a typographic solution.

10–17
Variations on a unique
Netcenter logo.

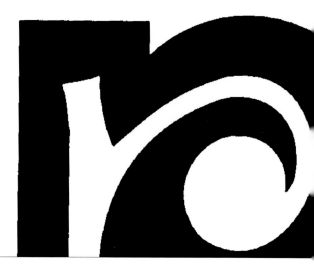

Raymond Pirouz's Identity

Raymond Pirouz
Alhambra, California

The Project

Raymond Pirouz is senior partner and creative director of R35, a digital design studio located in Alhambra, California. Raymond Pirouz is an expert developer of compelling visual communications and holds numerous awards for interactive Web design and advertisements for Honda, Cathay Pacific Airlines and the Fidelity Federal Bank. The California Institute of Technology, Virgin Records, Amnesty International and NASA are among his recent clients.

R35 is presented on the Web and accompanied by a second site, which focuses on Pirouz's personal presentation. This site is an interactive extension of his recently published book on Web design entitled "Click Here" and it also features his bio and a link to feedback and correspondence. For this new Web site Raymond Pirouz required an exclusive and distinctive logo.

The Briefing

Since Raymond Pirouz fulfilled the role of the client as well as the designer for this logo project, there was no literal or official briefing. However, Pirouz had to set his own criteria for developing a mark. The logo had to be a unique, simple and elegant representation of his identity and beliefs as a renowned media designer. Also, the logo had to be distinguishable in an expanding field of sophisticated Internet design. The mark would be employed as animation on the Web and as a static mark for

stationery and other print media. The target audience are the visitors of his personal site, specifically design professionals and potential clients.

The Process

Raymond Pirouz's initial approach was to create—within a strong conceptual definition—one visual symbol with multiple interpretations that depend on viewer perception. "I didn't want to go overboard with something that was too experimental or non-communicative," explains Pirouz. He understands quality design as a "fine balance between art and communication."

Abstract symbols were excluded at the outset of the process, since it was necessary for the mark to convey a highly personal look. Pirouz explored the utilization of letterform abbreviations in the search for distinguishable combinations for his two initials "R" and "P": he tested the effect of capital and lowercase letters and positive and negative typefaces.

According to Pirouz, the work process was not dictated by the medium. Moreover, the development of the logo was conceptualized through sketches on paper and not with computer software.

The design process lasted two days, including the concept and sketches. One day was needed to finalize the logo into vector art with Macromedia Freehand.

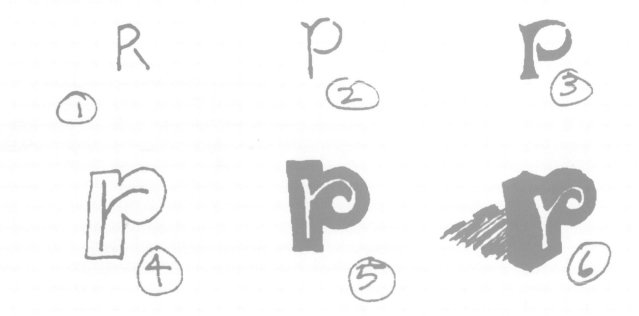

The Solution

The final logo evolved very smoothly from an original idea that combined Raymond Pirouz's initials, "R" and "P," into a lettermark. The "p" forms the outline for the letter "r," achieving a classical positive/negative effect in black and white. The choice of handwritten letters in lowercase lends a personal touch to the logo. As one logs onto the Web site, the animated letter "r" fades onto the screen and is surrounded, as it emerges, by the "p," as if one is virtually writing the monogram. When the links are opened, the mark changes to gray.

Although the idea of integrating the designer's initials into a mark isn't new, on the Internet simple conceptual marks like this one are a rare occurrence. The animation gives the logo life beyond print, creating an illusion of realism. The new identity symbolizes what Pirouz describes as "belief in simplicity and the harmonious coexistence of natural form and modernist structure."

The logo most frequently appears on the Web at www.rpirouz.com.

Above
Sketches for the animation of the logo.

Left
Raymond Pirouz's personal Web site with the new logo and Pirouz's second site, R35.

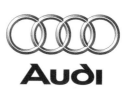

Audi

MetaDesign plus GmbH
Berlin, Germany

The Project

Founded in 1909, German car manufacturer Audi merged with the companies Horch, Wanderer and DKW in 1932 to become the Auto Union AG. The famous, overlapping four-ringed logo was then introduced. Each ring represents one of the companies. In the 1960s, the Auto Union AG was bought by auto manufacturer Volkswagen. In 1985 the corporation was renamed Audi AG.

Audi has become a major industry player in the production of high-performance passenger vehicles with a reputation built on technological excellence. Audi, however, has never developed consistent marketing strategies focusing or targeting a modern lifestyle or image. Also, they never established a unified branding plan; whereas the Audi logo on cars was the four rings, the mark on printed media showed oval lozenges. Audi utilized at least three different logos in four different colors carried throughout the corporation's numerous activities. By 1993, the overall jumble of aesthetics and the unclear market positioning resulted in a major identity crisis with attributed sales losses.

Audi faced the problem and defined its own values and positioning against major brands like BMW and Mercedes-Benz. The rebranding started in Audi's in-house design department: car models were simplified and renamed. The "Audi 80" became the "A4"; the "Audi 100" became the "A6."

The Briefing

In the end of 1994, Audi chose Germany's Berlin-based MetaDesign, with its international reputation for global design strategy, to develop a forward-looking corporate identity. MetaDesign was asked to:

- develop an overall corporate design;
- establish a dynamic, passionate and emotional CI to balance Audi's technical base;
- establish organized, corporate guidelines to ensure consistency of communication;
- accommodate the difficulties involved in the company's move towards globalization (focusing on key export markets and the founding of new production centers in Hungary and Brazil);
- reflect and promote the changes occurring within in a fast-developing organization, supporting the work of individuals who are attempting to move the company forward;
- respect Audi's long history;
- incorporate key qualities from existing values;
- develop an integrated CI, that the diversity of employees and partners would be able to implement;
- function as consultant for new media and apply latest expertise into the CI.

The complex task included the technical revision of the logo; the redesign of advertisements, brochures, CD-ROMs and Web pages; and the documentation of the new Audi architecture.

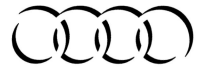

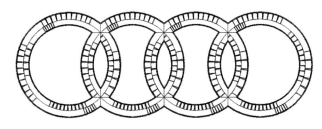

The new Audi clientele was characterized as socially responsible individuals who love their jobs and families and are interested in ecological issues.

The Process

MetaDesign reorganized its Berlin office, creating three teams to work specifically on the Audi project:

- corporate design
- Internet/online design
- CD-ROM (together with agency Jung von Matt, Hamburg).

Since Audi is an ongoing project, the teams remain in place today. These groups meet regularly with Audi's in-house design department in order to ensure a unified and interactive look consistent with new car designs. Teams are led by project managers and senior designers.

MetaDesign specializes in corporate design and takes a system-oriented approach. One goal was to create modular, flexible guidelines to enable a corporate design system to evolve along with the changes in the company. MetaDesign's objective for Audi's external communication was to achieve a subtle, consistent design pattern throughout the Audi corporation—representing Audi's character—no matter if a potential client sees advertisements in a magazine, logs onto the Audi Internet page, or visits one of the Audi Centers to look at the cars.

From the briefing it was evident that Audi was in search of secure, fast and effective communication solutions between their global dealerships and agencies. MetaDesign analyzed this process in detail and determined that major modifications needed to be conducted; brochures and CD-ROMs were a limited medium for getting guidelines across, because they don't allow for fast adjustments to changes made by Audi.

The Solution

MetaDesign developed a unified appearance to the Audi mark which is accessible to all markets and is media friendly to the target groups, external and internal. MetaDesign brought Audi's motto—"One Name. One Standard. Everywhere."—to life.

The four-ringed, black Audi symbol was first redesigned by Sedley Place Design, who gave it a three-dimensional look. A completely new design was not considered, because of the history the four rings have in the history of the company. The mark now appears in aluminum, representing the high quality of Audi's products. MetaDesign revised this new mark, data technologically, in different sizes and digitalized many versions for all possible applications. The new Audi logotype is a custom-designed letterform—exclusively developed by MetaDesign. Only the four Audi letters exist. The logotype appears as the only item within the CI in a

Above
The evolution of the Audi mark.

1
The redesign of the four rings by Hesse Design, Germany, in 1992–93.

2
The background ellipse of the new Audi wordmark, created by Sedley Place Design, was discarded to convey a less static and more advanced image.

3
The technical revision by MetaDesign.

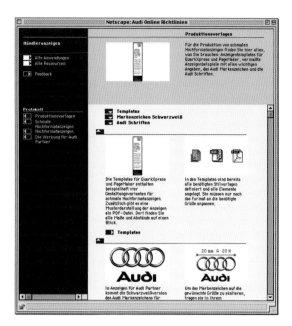

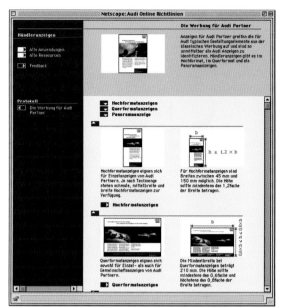

clear signal red. This color is never shown on larger areas intending to communicate an emotional statement.

The Rotis font—designed by the German Otl Aicher—and Audi's former corporate typeface was replaced by the Univers font. The Univers was modified by MetaDesign to the Audi Sans. MetaDesign also modified the Times to Audi Antiqua: Both were missing specific characters and personality necessary for the new desired Audi look. Furthermore, the Times didn't work well enough in a negative application. With its technical feel, the Audi Sans is used for headlines, texts and technical information. The Audi Antiqua appears sparingly on argumentation and in quotes. These customized typefaces are adjusted and convey the Audi image.

The new corporate colors are aluminum, white and red. These primary tones derive partially from the logo and play a major role in all communication materials: Red characterizes material for the dealerships, white signifies the corporation and aluminum is for the clients. Furthermore, aluminum has a symbolic meaning within the Audi corporation. It is the material of the chassis of the new 'Audi Space Frame' for the A8—it has highly positive connotations—overall, it stands for quality.

Audi's request for a dynamic image is achieved by the use of a "multipicture-look," asymmetrical layouts, crossed headline typography and multiple

design layers—on TV commercials as well as in the brochures and Web pages.

To ensure that the new design system is consistently utilized, nationally and internationally, by over 5,000 importers, dealers and agencies for advertisements, direct mail, car design, Internet, stationery and CD-ROMs, brochure manuals were acquired for Audi. The corporate design manual includes a clear definition of how Audi's brand should be conveyed. Aside from a visually aesthetic and carefully organized design, the major focus lies in the explanation of these guidelines. The Audi guidelines take a different approach from the usual manual: Its language and terminology focuses on the application, explaining the logic behind the system and helping each user employ the elements in a way that is both consistent with the system and appropriately localized. The manual is careful not to overload the user with too much information. It comes in four languages and is sensitive to target groups. For example, an importer needs a more generalized level of information, whereas a local agency responsible for the production of a brochure needs more detail.

With MetaDesign as a consultant for new media tasked with how to best keep design manuals updated, a new revolutionary computer corporate design program that utilizes the Internet for communication has been created. It is coined ERA, standing for Element, Rules and Application, the three-part

process of producing materials. Like the printed manual, ERA contains all the artwork necessary to do a job. The whole CI is split into its basic elements and is modeled by a databank. Via password, one enters the archive that contains info on color codes, fonts and style sheets.

If Audi is launching a new car model, elements have to be added to the guideline and set quickly, for the dealer as well as the agency and internationally. With ERA, the new individual elements can be easily woven into a complete application.

ERA uses interactivity to provide on-screen tutorials, to set up information forums and allow for question/answer sessions between individual users and MetaDesign.

ERA was developed over a course of two years with a group of ten people in the software department of MetaDesign. All of Audi's dealerships, importers and its two-hundred agencies have been connected to ERA since 1998.

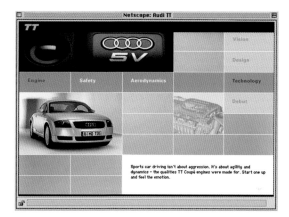

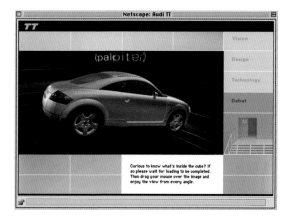

Above and Left

MetaDesign acts as a catalyst, researching the latest media technologies and analyzing and explaining how they might be applied to Audi's business. In this context three different Internet pages were developed. One is the "Worldsite" (www.audi.com), which brings the mark and the Audi image alive. A link leads to national "Marketsites" (for Germany, www.audi.de). This site contains more specific information on Audi products and equipment and links up to the "Dealership Site." This features a homepage and is divided into three sections: Models, Dialog and Service. The three distinctive Web pages make Audi's communication with their clients highly efficient. Eighteen developers are working continuously on software programs like Photoshop and BBEdit to develop the Audi Web site for the German market.

All sales and internal brochures utilize the same clear design pattern. Different colors indicate the different targeted groups. Whereas the adjustments made to the logomark are hardly visible, the overall multi-picture and multi-layered design is visually strong and consequently applied to all brochures, collateral, advertisements and Web pages. To MetaDesign, this structural approach to identity systems is most important.

Literature concept—Philipp Götz

Brochures—Deffner & Schormann

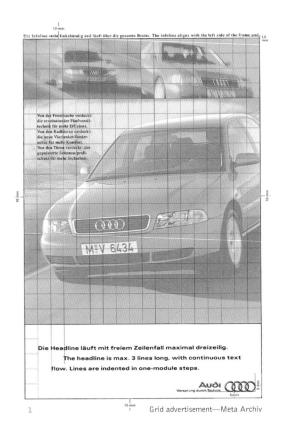

Die Infoline steht linksbündig und läuft über die gesamte Breite. The infoline aligns with the left side of the frame and.

Von der Fronthaube verdeckt:
die revolutionäre Fünfventil-
technik für mehr Effizienz.
Von den Radkästen verdeckt:
die neue Vierlenker-Vorder-
achse für mehr Komfort.
Von den Türen verdeckt: der
gepolsterte Seitenaufprall-
schutz für mehr Sicherheit.

Die Headline läuft mit freiem Zeilenfall maximal dreizeilig.
The headline is max. 3 lines long, with continuous text
flow. Lines are indented in one-module steps.

Audi
Vorsprung durch Technik

1 Grid advertisement—Meta Archiv

2 Showroom—Rainer Christoph

3 Showroom—Rainer Christoph

1
Example of Audi
advertisement.

2–3
Interior design of an
Audi showroom

4
The architecture of the
Audi hangar successfully
applies the same multi-
layered design concept
that was used for their
collateral and Web pages:
Here, it is shown through
a diversity of materials,
textures and patterns.

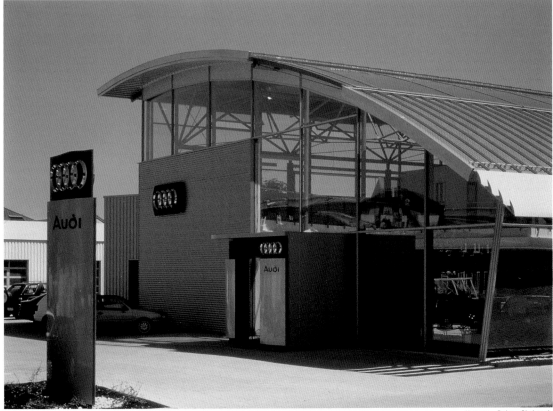

4 Hangar—Rainer Christoph

Metreon—A Sony Entertainment Center

Pentagram
San Francisco, California

The Project

Metreon is the brand name for a new generation of entertainment centers developed by Sony Inc. Metreon will be an indoor facility, located in selected American, European and Asian cities as part of an effort to improve inner city districts.

The first Metreon, adjacent to the San Francisco Museum of Modern Art and the Yerba Buena Gardens in San Francisco, California, opened in 1999. This prototype for Metreon, with an area of approximately 350,000 square feet, offers fifteen theaters, retail components and restaurants.

The center features entertainment spaces, including an interactive exhibit called "How Things Work"; a space in which the characters of the book "Where the Wild Things Are" come to life; and something called the "Airtype Garage," an interactive space created by the French comic illustrator Moebius. The "Metreon Marketplace" is organized like a street fair with small kiosks offering the "latest undiscovered treasure." Local chefs offer regional cuisine called "The Taste of the City." Metreon's focus is on global as well as local culture, and the center is also intended as a gathering place "to catch a movie, eat, play, shop, learn or just spend some time," according to Sony.

The Briefing

Sony asked Pentagram San Francisco to create a logo for Metreon that fullfills the following criteria:

- communicates an international as well as local character, since Metreon should attract tourists as well as inhabitants of San Francisco;
- has a sophisticated look that stands out from existing entertainment centers and conveys its unique concept;
- represents the "fabric of the city" and its roots, and is an urban gathering place;
- attracts audiences of all ages and cultural backgrounds;
- works in most diverse applications: print media, signage, way-finding system, architecture and an animated version for the Web.

Pentagram was asked to develop the signage and the way-finding system for the center to go along with the identity.

The Process

Pentagram's initial brainstorming included hundreds of design possibilities. A structural guideline for the first Sony presentation was organized and sent through an internal review. Pentagram narrowed the ideas down to three major directions:

- metaphors, with suggested key words "zap," "pow," "splat";
- symbols, with a focus on people, entertainment and gathering places;
- typography, with a focus on literal personality.

These directions were explored, reselected and presented to Sony. This review revealed that a single symbol solution was not appropriate for Metreon,

since the new entity was in need of introduction to, and positioning in, the market. Also, several solutions with a modified, three-dimensional, iconic "m" in conjunction with the letterform "Metreon" were refused for similar reasons. The icon could not be used separately from the name, since it would not be self-explanatory. The solution had to be a purely typographical treatment or variation on the Metreon name. Pentagram needed a clear, bold translation of the name Metreon that would subtly allude to old Broadway theater fonts and the urban culture of the 1930s and 1940s, Art Deco and Odéon.

The design process comprised five different selection phases over a period of six months, which included various presentations to Sony.

A typical presentation by Pentagram includes a video projection of the proposals. Additionally, the client receives a summarized version of the presentation in a unique booklet.

The Solution
The final logo is a lettermark with a modified font, which is a symbol in itself. The crossbars of the letter "e" have been horizontally positioned in line with the existing crossbars of the letter "r." The font, with its sharp ends, captures the flavor of Art Deco. The contrasting color red was chosen for its passionate and active connotations—it has a simple yet outstanding

effect. The logo appears together with "A Sony Entertainment Center," which is set in Futura.

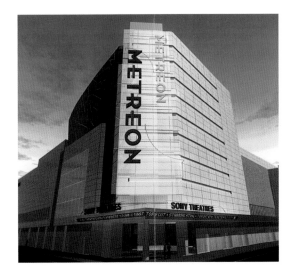

ERAS Center
Evenson Design Group
Culver City, California

The Project
Since 1980, the ERAS Center, a nonprofit, interdisciplinary leader in educational, vocational and community concerns, has provided service and resources to individuals and families at various degrees of risk. ERAS trains professionals and assists children and young adults challenged by learning. The center provides therapy for the chronically disabled and develops models for integrating the needs of the community in general. Over 400 individuals per week use ERAS Center's resources.

The Briefing
The Evenson Design Group was asked to design a mark that reflected the philosophy and desire of the ERAS Center to transform children and adults at risk while allowing them to blossom and develop their maximum potential.

The target market ranges from parents looking for a healthy environment in which their children can learn and grow to corporations and government agencies whom the ERAS Center recruits for sponsorship or funding.

The Process
EDG's goal was to visually convey the following scenario: An individual enters the ERAS Center, and with special nurturing and caring transforms over time into an individual who can contribute to society and the community at large.

The previous logo (the ERAS owl) was designed by a former ERAS Center student—the designer's mother was on the board of directors and a major fund-raiser.

The new process involved the executive director from the very first presentation and included over twenty different logotype solutions. The choices were then narrowed down to the final outstanding mark. The executive director required another presentation before the board of trustees to explain the concept behind the logo.

The Solution
The new mark uses four panels to represent a process. Each panel shows progressive development from left to right. The first panel contains a small jagged tree branch, denoting the beginning of the process. Through the ERAS Center's process of nurturing, the branch develops leaves, and then takes on the shape of a human hand. This is metaphorical of the ERAS Center transformation.

Since the center is a nonprofit organization, the idea was to cut costs wherever possible. The logo is designed with three colors but effectively translates into two- or one-color solutions to meet budget constraints. The logo appears most frequently on print collateral, videos and the ERAS Center's Web page.

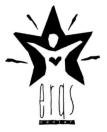
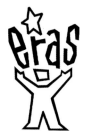
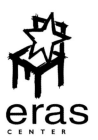

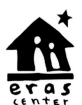

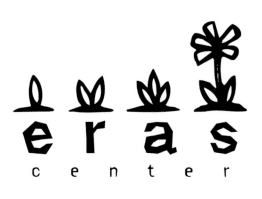

nike

nike

Nike

Nike Inc.

Beaverton, Oregon

The Swoosh design emerged on nearly all merchandise and Nike wondered if it was losing its impact. Nike committed its in-house design department to developing a strategy for a new application of the logo that regulates the usage of the mark on all products, advertisements and corporate stationary.

The Project

Nike, Inc. is the world's leading developer of sports and fitness products. Founded in 1962 by track coach Bill Bowerman and athlete, Phil Knight, its forerunner was BRS, or Blue Ribbon Sports, which was created to achieve the exclusivity of the American distribution of the Japanese-made "Tiger" sports shoes. Soon thereafter, Nike was launched. Named after the Greek Goddess of Victory, Nike made its global debut at the 1972 U.S. Olympic Trials. Carolyn Davidson, a student at the time, designed the wing-like Swoosh design for a fee of thirty-five dollars. It was outlined and formed the background of the name which was set in lowercase italics.

With the goal of becoming a leader in optimum performance athletic shoes, the company invented lightweight designs and technical advances for the sports industry. The development of the air-cushioned sole, called Nike-Air, which was spawned by former NASA engineer Frank Rudy, and the birth of certain high-tech fabrics brought Nike worldwide successes.

Nike's media campaigns brought a new, hip image to sports fashion, featuring star athletes like Andre Agassi, Bo Jackson and Michael Jordan in their highly effective advertisements. In 1988, Nike targeted the American competitive spirit with the catchy slogan, "Just do it". It appealed to a vast consumer group. The campaign became enormously successful and sales grew rapidly. Nike had reached across sales markets by depicting the popular life styles of a generation. The famous logo, dubbed the Swoosh design, became a pop icon. It is prevalent worldwide.

The Briefing

While visiting a football game in Dallas, Texas, Gordon Thompson, Nike's Design Vice President, noticed that the Swoosh design logo was presented in various sizes and numerous times on each Dallas Cowboy uniform, on flags, vendors and other team items—"There were too many Swoosh design logos, it was totally overloaded" says Thompson.

Nike committed its in-house design department to developing a strategy for the application of the logo that systemizes its application on 20,000 products marketed yearly, on web sites, the stock market and internal corporate uses as well. Special emphasis was placed on flexibility and diversity.

The Process

The design department analyzed their products, marketing campaigns, merchandise and services to determine and categorize where reapplication of the logo was most needed.

The Solution

Nike strategically applied the Nike name and Swoosh design by assigning them different functions within the corporate identity. Two kinds of brand characters are now distinguished.

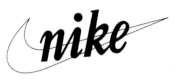

It's our signature and our voice.

It's what we use when we speak. It's a

distinction at the highest level between

who we are and what we make.

nike

5

The Swoosh design is the product designator and therefore is shown on all products and product advertisements. The Nike name underwent a major change; the sleek character of the capital oblique letters in conjunction with the dynamic Swoosh design was oversaturated with a sportive effect. To remedy this imbalance, the original Nike name from the 1970s with its lowercase italic letters was redesigned and applied. Nike wished to allude to its strong heritage. " Its potency (the 1970s trade-mark) is in its history and its originality. This is not about nostalgia, however—it's about passion. It's our signature and our voice," says Nike. The Nike name is used as the Brand communications signature and appears on all corporate stationary, public service or corporate image campaigns as well as in the stock market.

With this new strategy, the Swoosh design plays a more distinctive, appropriate and valued role within Nike's identity program and has significantly less oversaturation.

Above
The evolution of the Nike mark.

1
In 1971, the first version of the Swoosh design logo was designed by student Carolyn Davidson—since Nike is the Greek Goddess of Victory who had wings, the symbol is an appropri-ate abstraction for athletes shoes.

2
By 1978, the Nike name and Swoosh design had changed: the Swoosh design, now solid instead of outlined, is positioned below the Nike name, getting a more prominent function.

3
In 1985, the Nike mark was reversed and posi-tioned inside a square.

4
Today, the Swoosh design appears separated from the Nike name, depending on its purposes.

5
In a statement, Nike explains the new usage of the Nike name and the Swoosh design.

1

The old and the new mark in comparison: while maintaining the main qualities, the original trademark from the 1970s (left) underwent minor, but effective typographical changes to become the new Nike name. The letterspacing was altered to create rhythm, the upward slant was changed in favor of the horizontal axis, the "i" and "k" were connected to unify the letters and create a flow. Also, the "n" was altered to connect with the "i" at the bottom— rather than at the top — to improve readability.

2–6

Excerpt of Nike's CI manual: Visually clearly distinguishable, the corporate guidelines show the do's (white background) and dont's (Black background) for all possible application questions.

2

Many applications of the revised Nike name such as on signage, packaging and corporate communications require a "holding line" to ground the mark. The "holding line" bleeds off the background space.

3

Nike's CI guideline demonstrates exact placement rules for the Nike name.

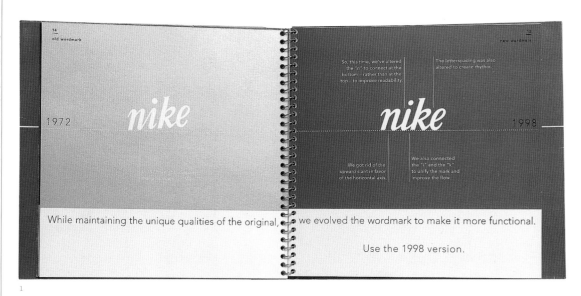

1

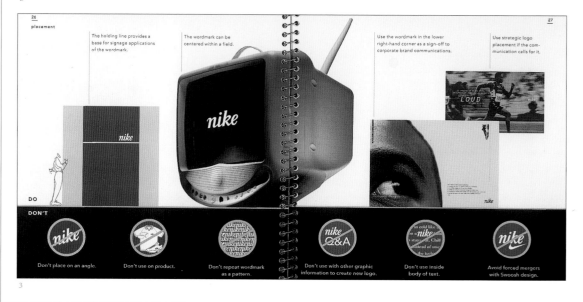

2

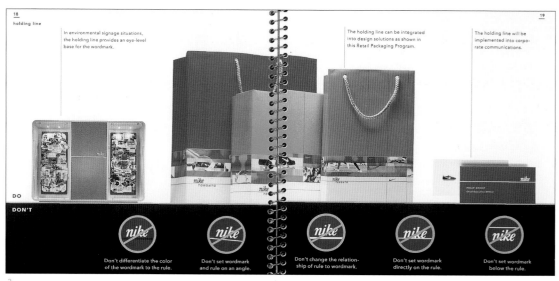

3

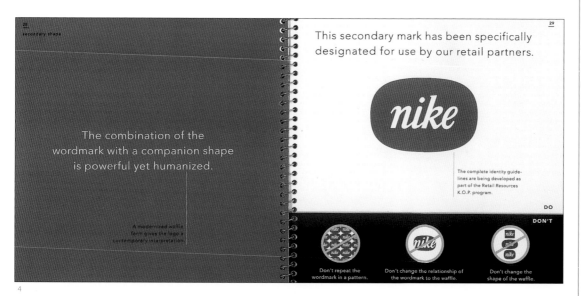

28
secondary shape

The combination of the wordmark with a companion shape is powerful yet humanized.

A modernized waffle form gives the logo a contemporary interpretation.

29

This secondary mark has been specifically designated for use by our retail partners.

The complete identity guidelines are being developed as part of the Retail Resources K.O.P. program.

DO

DON'T

Don't repeat the wordmark in a pattern.

Don't change the relationship of the wordmark to the waffle.

Don't change the shape of the waffle.

4

In addition to the stand alone version supported by the "holding line", Nike offers its retail partners the usage of the Nike name positioned in a "waffle" form.

4

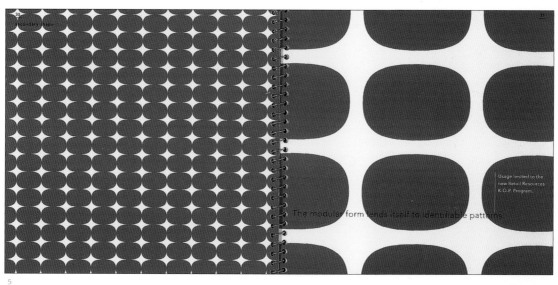

30
secondary shape

31

Usage limited to the new Retail Resources K.O.P. Program.

The modular form lends itself to identifiable patterns.

5

To increase the design flexibility, the "waffle" shape can also be used as a pattern, if kept in the right proportions and distances from each other.

5

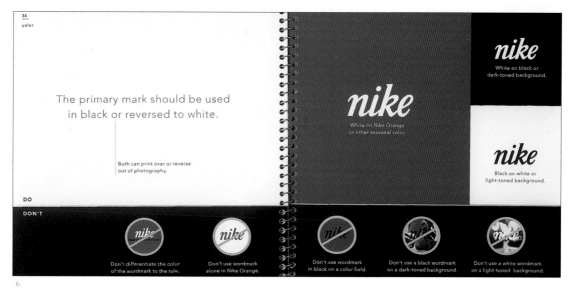

34
color

The primary mark should be used in black or reversed to white.

Both can print over or reverse out of photography.

DO

DON'T

White on black or dark-toned background.

White on Nike Orange or other seasonal color.

Black on white or light-toned background.

Don't differentiate the color of the wordmark to the rule.

Don't use wordmark alone in Nike Orange.

Don't use wordmark in black on a color field.

Don't use a black wordmark on a dark-toned background.

Don't use a white wordmark on a light-toned background.

6

Color application rules for the Nike name.

6

SYMBOLIC/INDEXIC MARKS

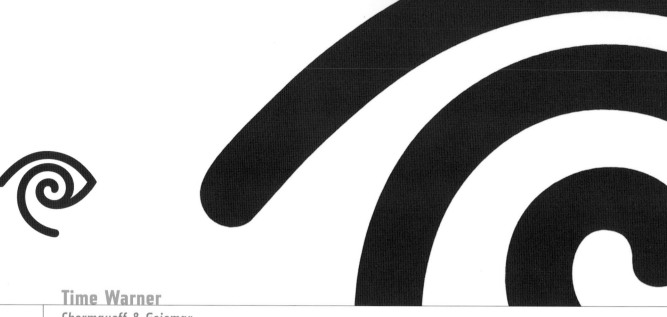

Time Warner

Chermayeff & Geismar

New York, New York

The Project

In 1989, the publisher, Time Inc., and Warner Communications, the entertainment company, merged to become America's largest entertainment conglomerate. The new merger was named Time Warner Inc. with headquarters in New York City. An incorporating identity was needed.

The Briefing

Chermayeff & Geismar Inc. were commissioned to develop an identity that would accommodate various entertainment media as well as traditional printing needs. The logo should be accessible to a wide audience. This required a prominent look, clearly identifiable regardless of cultural or educational background.

Time Warner Inc. wanted a departure from the look of previous marks despite successes with such logos as the one designed by the pioneer designer, Saul Bass (1920–1996).

The Process

Time Warner's Chairmen N.J. Nicolas and Steven J. Ross presented Chermayeff & Geismar with the redefined and simplified name (Time Warner) which eliminated the additions "Inc." and "Communications." Since it was clear that the corporation was not in need of repositioning or new marketing, the design problem centered on a pure graphic identity for the merged company.

During an initial analytical phase, Chermayeff & Geismar conducted a series of interviews with Time Warner executives that helped build a character that could then be graphically portrayed. Steff Geissbuhler, Ivan Chermayeff and Tom Geismar were involved and carried out the first phase of the preliminary designs. The series was then narrowed down to three promising directions. One approach was to translate Time Warner literally into a single word logotype. Another proposal used the initials "TW" like a two-letter monogram combination. In all, hundreds of letterforms were tested. The logo's accessibility was a priority, in part because of the diversity of media and displays, such as future communications, magazines, cassettes, books and animation for TV and film, in which it would be used. Consequently, Steff Geissbuhler made the decision to explore and develop a symbol mark. It was essential to create a symbol that would reflect both journalism and entertainment. The essence or common denominator of the two businesses was revealing. Looking and listening, reading and hearing, receiving and sending are the activities that relate to both companies, i.e. entertainment and journalism.

This all led to a simple statement that captures the essence of Time Warner's products: "Time Warner —the eyes and ears of the world." Finding the right simplified abstraction for an ear, however, was challenging, because the ear's natural form is amorphic

and complex. Shape and line developments and refinements were designed from scratch in Adobe Illustrator on the Mac. This attempt, however, failed to achieve subtleties in certain curves. So Steff Geissbuhler took a printout from the computer and painted the eye/ear symbol over it with a brush. It was then scanned into the Mac and the irregularities were smoothed out, cleaning up the image.

The design was developed within a month. Because the companies had already merged, the schedule was fairly tight. The entire process until implementation, however, took almost half a year.

The Solution

On Earth Day of 1990, the new logo, an eye/ear pictograph, premiered on a two-hour Earth Day television broadcast that Time Warner sponsored. To emphasize the merger, the two corporate names were combined into one word, TIMEWARNER, in capital letters, with the eye/ear pictograph. It is a subtle treatment that portrays the new name in a simple and powerful way. Immediately distinguishable and easy to relate to, the eye/ear symbol is a strong pragmatic solution that is not too abstract. It's effective as animation, can be enlarged on signage, and reads well in both large and small versions.

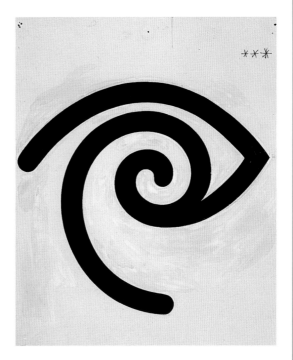

Above
The process can be tricky—the logo layout and solution were already decided upon. However, the desired shape for the curves could not be achieved with conventional computer software. When Steff Geissbuhler used a printout from the computer to create the curves for the eye/ear symbol, a brush was the right tool to accomplish the desired effect.

Above
An initial idea explored
the possibilities with
the two initials as
a monogram.

1
To visualize the merger
within an advertisement,
the two elements of the
symbol—eye and ear—
were first taken apart and
then put back together.

For the introductory ads, George Lois from the agency Lois/GGK hooked up with the overall concept of simply visualizing the merger: The two elements—eye and ear—were first taken apart and then put back together. The animation for the logo was created by the filmmaker Ridley Scott, who had directed films like "Alien" and "Blade Runner" among other successes.

After the death of chairman Steven Ross in 1993, Gerald M. Levin became the new president and the logo was changed again. Levin wanted to set his own accent and found the eye/ear symbol too strong: "It's hard to make it work with other divisional symbols," he says. The symbol logo disappeared; the new logotype became "Time Warner," framed by two lines. The use of the eye/ear symbol, however, continues for Time Warner Cable and is painted on company trucks and used in printed public media. Also, Time Warner's in-house design office changed the typeface from Futura to Copperplate Gothic font.

2
In comparison: The indexic
mark as it was invented by
Chermayeff& Geismar Inc.
and below, Time Warner's
newest identity, a
simple logotype. There
is clear visual excellency in
the eye/ear logo.

WITH ALL OF US
LOOKING...

AND LISTENING...

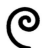

WE ARE BECOMING
ONE WORLD

TIME WARNER

TIME WARNER

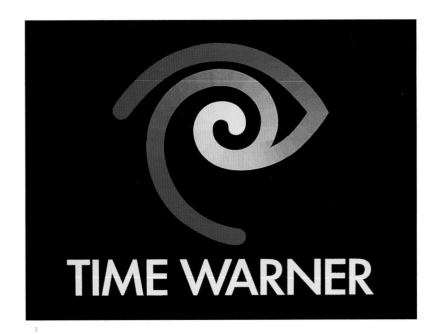

3

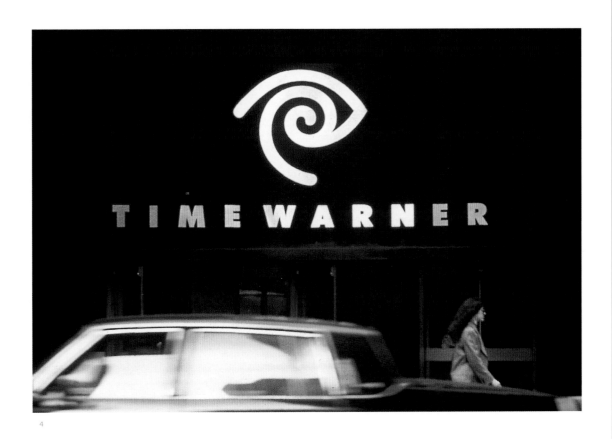

4

3
An earlier presentation composition, before Time Warner became one word.

4
The final signage at Time Warner's headquarters.

CHICAGO
SYMPHONY
ORCHESTRA

Chicago Orchestra Hall

Carbone Smolan Associates
New York, New York

Carbone Smolan Associates were asked to visually unify the orchestra, its diverse activities, and the city of Chicago with a strong and consistent brand identity directed at a young and curious, rather than a refined, audience.

The Project

In 1994 the architect firm Skidmore, Owings & Merrill was challenged with joining the original Chicago Orchestra Hall with four office towers, creating a complex of five structures totaling 360,000 square feet. The new facility would include an interactive education center for children, a restaurant, an artistic support building, administrative offices and a public arcade. In 1997 the Chicago Symphony Orchestra opened the new Symphony Center with a Grand Gala.

In order to inform the greatly expanded audience and seamlessly guide them through the center, a new identity and environmental graphics—including donor recognition and a comprehensive program of way-finding—were needed.

The Briefing

Carbone Smolan Associates were asked to portray the orchestra and its related entities as lively, vibrant and forward-thinking. Furthermore, they were asked to visually unify the orchestra, its diverse activities, and the city of Chicago with a strong and consistent brand identity directed at a young and curious, rather than a refined, audience.

The Process

Carbone Smolan Associates have worked with the Orchestral Association and Skidmore, Owings & Merrill for three years to develop the program. Initial explorations for the logo design were broadranging, including variations on the image of a cardinal, the state bird, and detailed tonal depictions. Three presentations were given at two-week intervals and nine design objectives were proposed. From these, three were chosen for further development; a final direction emerged and was refined.

The Solution

The new identity portrays a dynamic and stylized "C." The logo playfully defines the movement and structure of music and the orchestra as well, evoking a crescendo effect through a rich and exciting color palette. It is a harbinger for the respected institution's revitalization of spirit and inaugurates the new century. For Carbone Smolan Associates, an important criterion was an autonomous symbol that would be equally appropriate for a seal of approval, program initiatives, marketing efforts and consumer merchandise.

Above
These initial logos were too static and did not communicate to the desired and targeted younger audience.

Left
The final logo can be used with different background colors, depending on its purpose.

Enlarged sections of the logo can be manipulated and utilized for various motives, portraying rhythmic movements and other more playful design elements.

The implementation of the symbolic mark in different mediums including banners, brochures and stationery.

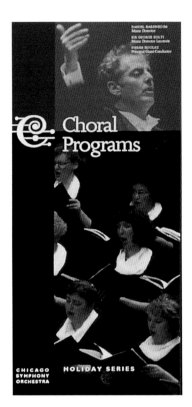

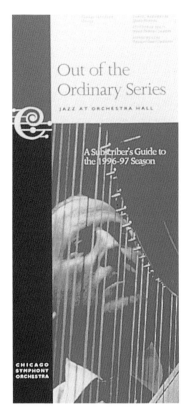

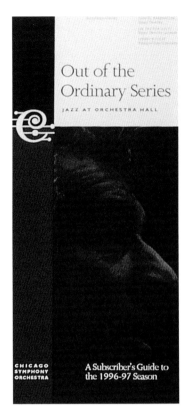

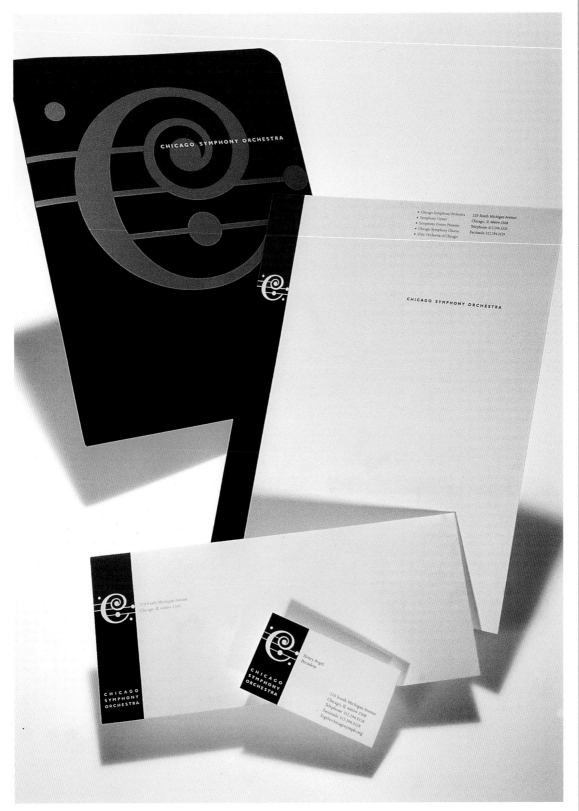

The logo background is like a column consisting of two colors. This is a variable and can be enlarged, reduced or extended.

"The final symbol developed into a tighter, more organized representation of the musical staff and letter 'C' than was originally envisioned. The result is a stronger and more contained gesture."
—Carbone Smolan Associates

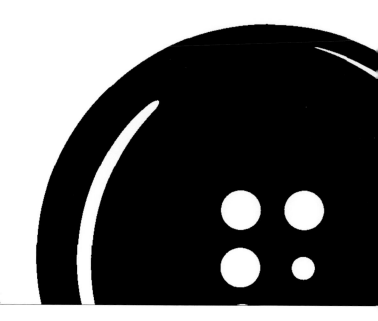

THE FASHION CENTER

The Fashion Center, New York

Pentagram

New York, New York

Since the Fashion Center District had no identifying visual mark setting it apart as a newly created district in New York, Pentagram was asked to design a prominent icon labeling an area of mostly multiple-storage buildings.

The Project

The Fashion Center is one of New York City's business improvement districts, dedicated to its urban neighborhood and businesses, which include 175,000 designers, manufacturers, stylists, models, wholesalers and retailers. Comprising Manhattan's traditional garment center and located on Seventh Avenue, The Fashion Center works to improve the quality of life for people who work, visit and do business in the fashion industry. The Fashion Center's business improvement district (BID) was formed by property owners who wanted to take an active role in improving their part of the city. The BID develops private security, sanitation, marketing and promotional programs for its constituency. Because the Garment District had no real geographic or architectural center, the BID intended to install an information kiosk that would become a part of a whole new graphic identity.

The Briefing

Since the Fashion Center zone had no identifying visual mark setting it apart as a newly developed "arrondissement" in Manhattan, Pentagram was asked to design a prominent icon labeling an area of mostly multiple-storage buildings.

The target group is the general public with the subsection of the fashion industry which is one of New York's most profitable industries.

The Process

The designers' objective was to find a clear mark that would be highly visible within the confusion of the streetscape. The familiar notion of using the word "fashion" within a logotype was abandoned almost immediately because of its overusage. Instead, it was decided that something like New York's apple icon might be more appropriate. Initial icon ideas included dress hangers, textiles and needles, all of which proved visually too complicated.

The Solution

The solution is a whimsical button symbolizing the trade and the organization. Because color is a subject of contention among designers, the button appears in black. Also, the mark has an extra hole that creates a subliminal "F," for fashion.

The logo appears on newsletters, in advertisements and on street banners which promote the activities of the Center during New York's fashion market weeks. It remains on trash receptacles and worker uniforms year-round.

In 1996 the three-dimensional translation of the logo was incorporated into a kiosk in the heart of the Fashion District at 38th Street and Broadway. An octagonally shaped booth was topped with a sixteen-foot diameter button logo supported by a thirty-foot long stainless steel needle. To extend the

metaphor, the attendant's desk in the booth consists of half of a giant spool of thread. The kiosk was created within a year, whereas the logo was designed in a month. The application of the mark in the district took an additional couple of months. The architecture for the kiosk won a 1995 Honor Award from New York City's Art Commission.

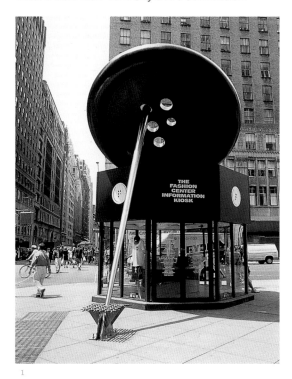

1

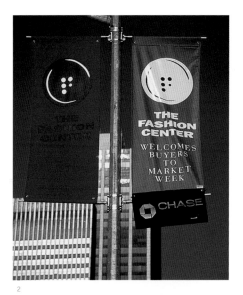

2

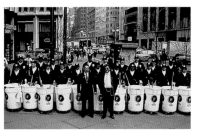

3

Bradesco

Banco Bradesco

Landor Associates
San Francisco, California

The complex project consisted of a communication system that would better clarify and organize the many messages the bank sends out daily to a large clientele, including commercial, retail, insurance and investment interests.

The Project
With their headquarters in São Paulo, Brazil, Banco Bradesco is Latin America's largest private bank, with over 2,000 branches in Brazil. On average, 6,000 new checking accounts are opened daily. The bank has 2.5 million shareholders and is Brazil's only bank offering checking accounts to poor and lower class citizens. Banco Bradesco's identity has existed for over fifty years and belied its advanced technologies and approach.

The Briefing
In 1995 Landor Associates were asked to develop a brand strategy and identity for Banco Bradesco that better communicated the technological sophistication and reorganization of the bank.

The task included the development and implementation of the new identity for Web design, ATM screen interface and kiosk interface design. The identity needed additional application to both divisions of Banco Bradesco: Seguros Bradesco, an insurance company that is Bradesco's largest and most independent division, and Bradesco Foundation, a philanthropic enterprise dedicated to providing educational opportunities for children of lower income households.

The complex project consisted of a corresponding communication system, conceived by Landor Associates, that would better clarify and organize the many messages the bank sends out daily to its large clientele, which includes commercial, retail, insurance and investment interests.

The Process
Landor Associates started with an intensive research analysis of the different departments of Banco Bradesco.

Based on the results, Landor developed a list of identity criteria to define an approach to a strong mark for a non-American, very alternative Latin-American audience. The criteria for the identity were as follows:

1. must help overcome widespread perceptions of the bank as slow, bureaucratic, and not particularly customer-oriented;
2. must herald the fact that the bank has acquired technologically advanced state-of-the-art electronic banking solutions: ATMs, online transactions, instantaneous data processing, etc.;
3. must communicate the desired attributes of speed, precision, agility and customer service;
4. must project the appearance of stability and reliability, attributes imperative in a volatile economy such as Brazil's;
5. must support the notion that Bradesco is "a Brazilian bank with the ability to act globally" —in other words: local touch, global reach;

1-2

3-5

1
This mark in upper/lower-case bespeaks accessibility, friendliness and customer service. "Bra" is the international abbreviation for "Brazil." The interlocking of the "a" and "d" symbolizes the strong bond between the bank and the Brazilian economy. Although conceptually acceptable, the bank wanted a symbol-oriented logo.

2
The second candidate was rejected because the bird symbol seemed too playful.

3
Although this idea depicts stairs that go upward, suggesting optimism and opportunity, and the diamond shape alludes to the Brazilian flag, this idea was rejected because the upward stairs indicate "too much work."

4
The fourth candidate depicts an "open door" and "red carpet," suggesting customer service, accessibility and full-service orientation. The bank believed this identity emphasized "looking to the past," rather than projecting the future.

5
The bank approved this concept of a tree as a potentially powerful symbol (strength, shelter, branches, roots, growth), but post-design consumer testing rejected the rendition as looking "rural, not progressive, not technological."

- must be a symbol identity (versus a wordmark) that allows the bank to eventually use the symbol alone as a "shorthand" identifier;
- must be timeless, not trendy, to avoid becoming dated in a few years' time;
- must be compatible with ongoing branch network environmental and branding initiatives;
- must retain the existing Bradesco colors, red and gray;
- must be functional and adaptable to a wide variety of media processes: embossing, digitalization, silkscreen/flexography, die-cutting, embroidery, one-color applications, halftones, animation, etc.

Five different strategies were pursued and tested within Brazil, some of which failed because of unforeseen cultural perceptions. The whole design process took one year.

The Solution
The final brandmark shows an abstract tree formed by four strokes; two are dynamic and two are vertically parallel and represent a cityscape. The logo was chosen because of the following attributes:

- the abstract tree is a powerful symbol for strength and shelter, and contains strong elements: fruit, branches, roots and growth;
- the left arc alludes to the projection of the sky over Brazil as in the Brazilian flag;
- the right arc suggests a banner similar to the one that crosses the Brazilian flag and bears the motto "order and progress";
- the intersection of the two arcs suggests connection, networking and the bank's bond to its customers;
- together these quick dynamic strokes symbolize the bank's agility and speed in customer service and satisfaction;
- the two vertical strokes forming the trunk of the tree—one small, one large—suggest the bank's commitment to each customer, regardless of size, power or wealth. The strokes also describe a bar graph on the ascendency, suggesting the bank's optimism about the future of the Brazilian economy.

This identity was integrated, at least partially, in all of the bank's marketing initiatives.

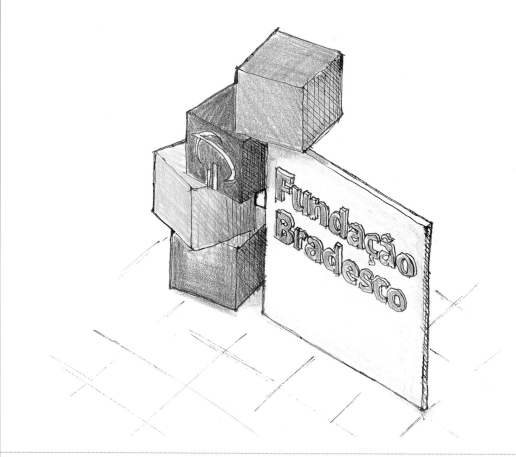

Sculptural application of the final logo as part of the identity sign system for Fundação Bradesco, a foundation dedicated to the education of children of lower income households.

Right

Primary identity sign system for Bradesco Seguros, an insurance company, visually links the company to Bradesco and at the same time differentiates itself through the use of forms and colors unique to the insurance market.

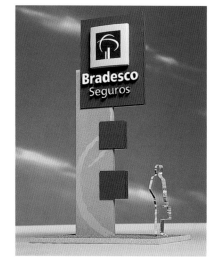

Far right

Original Bradesco bank signing. Bradesco assumed that retrofitting their existing signs would be a cost effective solution for resigning over 2000 branch locations. After Landor's evaluation of this solution, it was proven that a fresh, distinctive modular system (opposite) would cost almost the same as retrofitting.

The presentation to the client included the application of the logo onto various merchandise products and stationery, including the bank's credit cards.

 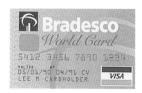 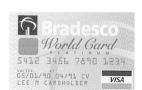

Brand attributes found in the identity have been introduced into Bradesco's new ATM environments as well as the new modular bank sign system. Curved forms and clean lines speak to Bradesco's innovative qualities.

Equity Marketing

Alexander Isley Inc.
Redding, Connecticut

Alexander Isley Inc. was asked to design the new logo to look more accessible, distinctive and fun. It would be used for Equity Marketing as well as for its two subsidiaries, and would make its debut on packaging.

The Project

Equity Marketing Inc., located in Los Angeles, California, is a manufacturer and distributor of licensed toys. The company designs, develops, produces and markets a wide variety of products based on characters from popular entertainment properties. Equity Marketing Inc. holds two subsidiaries, Equity Toys and Equity Promotion.

The Briefing

Since Equity Marketing Inc.'s expansion into new consumer areas, their corporate logo had become obsolete. A fresh and comprehensive image that would visually cohere to their toy business was essential. Alexander Isley Inc. was asked to design the new logo to look more accessible, distinctive and fun. It would be used for Equity Marketing as well as for its two subsidiaries and would make its debut on packaging.

The Process

"An effective identity should take its cue from the name of the company and the nature of its business," says Alexander Isley. "What is Equity Marketing and what do they do? What makes them different? And how is it possible to get this personality across in a logo?" are questions Isley believes are the best way to start the design process and define major directions. The objective was to create an easily identifiable mark that represents Equity Marketing's new positioning and goals. Initial explorations included letterforms of the client's name. The stacking of type helped consolidate the

rather long name, but it still lacked personality. The following design criteria were introduced:

- direct relationship to toys and fun, incorporating an uncommon element of surprise or delight, while maintaining an undercurrent of responsibility;
- flexibility; since Equity's role had expanded in the marketplace, it directly addressed end-use consumers, kids and parents, along with film studios and the investment community;
- a symbol that works equally well with the name of the parent company and the names of its subsidiaries;
- a clear and easy symbol to offer a balancing contrast to the dry and corporate nomenclature "Equity Marketing Inc.";
- a symbol that provides a spirited and memorable representation of the names, since Equity's name would appear for the first time on packages and promotional material.

Explorations for a symbol solution included the usage of the initials "EMI" (Equity Marketing Inc.), and "ET" and "EP" for the subsidiaries. However, because the initials would not be effective without additional explanation and did not exude the personality the design team intended, this solution failed. Isley's next strategy was to concentrate on the word "Equity." Equity is a strong word that is shared by the company and its subsidiaries. With its positive connotations, it is a conceptually ideal word to base an identity on. The difficulty was that

the letterforms did not look good together; they also did not allow for the creation of ligatures or letter modifications.

For the purpose of creating a compact symbol, the usage of the single letter "e" was then investigated. The question was whether to use the capital "E" that would represent solidity, permanence and rigidity, or the lowercase "e," which connotes informality, surprise and youth. Because its circular shape was ideal, as it gives the most flexibility with regard to the application of a mark, the lowercase "e" became the basic element for the new Equity symbol. The designers chose a bold, sans serif font to ensure that the letter could be reproduced in a smaller size and dropped out of a colored background, and its color modified. These are important considerations when applying a logo to packaging or marketing material. Finally, the design team had to consider how to transform the letter into an outstanding mark that communicates the personality and uniqueness of Equity. The whole design process took six weeks.

The Solution

With the intricate addition of a dot in the center of the letter "e," Alexander Isley Inc. turned the simple letter into a symbol that conveys fun, spirit and attitude. At first glance it looks official, bold, clean and graphic, but it has a twist. This mark represents the unconventional, frivolous and exciting nature of Equity Marketing. It is a simple, smart and memorable solution, effectively presenting the

main company and its subsidiaries. It can be utilized in a variety of sizes and colors and is conducive to various applications, including alternative name configurations.

Equity Marketing

Equity Toys
A DIVISION OF EQUITY MARKETING INC.

Equity Promotions
A DIVISION OF EQUITY MARKETING INC.

The Presbyterian Church

Malcolm Grear Designers
Providence, Rhode Island

The Project

In 1983, after 122 years of separation dating from the Civil War, the previously separated divisions of the Presbyterian Church joined to form the United Presbyterian Church of America. A committee of the Presbyterian General Assembly was subsequently instructed to bring an official seal to the Church.

The Briefing

Malcolm Grear Designers were hired to design an identity incorporating specific theological symbols representing the Presbyterian Church. The Church wanted an enduring symbol with meaningful imagery and a strong, formal basis. Malcolm Grear Designers were advised to utilize the cross as the mark's central image because of its currency as the most ecumenical of Christian symbols. The new mark should also include fire, a descending dove and the Bible. This project targeted anyone involved with the Church, including ministers, elders and lay members.

The Process

Initial ideas included pictorial images that were too literal and artistic. Other studies were too trendy and would be subject to changing styles; some were what Grear calls "computer swooshes." Consequently the decision was made that the symbol should have a structurally ordered quality.

Grear describes the remarkable peculiarities of the project: "We accepted the contract under unusual conditions, allowing a nine-member committee to come in and view our design process. We stipulated that they were not allowed to make changes in a particular design; they [had to] either accept or reject our design, but [were] not [allowed] to pick it apart. Normally we would not want a client to make judgments before we have arrived at something which we feel strong about. So, we made the decision that we would arrive at a symbol that would measure up to our standards when the committee [was scheduled to] come six weeks later. We did hundreds of sketches, but could not move beyond pictorial images of a bird and a book. I came down hard on myself, fearing that I was losing my zip. I worked on the logo possibilities all day and most of every night, and dreamed about the symbol during whatever time was left for sleep. Then, I finally reached something I felt was right. I made a tall hat with the symbol on it and paraded through the studio to cheers....This was at two o'clock in the morning. The nine-member committee was to arrive at nine o'clock the same morning." After the General Assembly approved the logo design, it was submitted to a forty-member board and finally to a 700-member Governing Board that determined the final acceptance.

The Solution

The final logo shows a consistent structural concept that includes eight different symbol variations with a common design basis. The symbol unifies the images of the Bible, the Holy Spirit, the ascending dove, flames of the Burning Bush and the Celtic

Cross. During the design and consultation process, other relevant religious images emerged, such as the triangle that stands for the Holy Trinity; the fish, an early symbol of Christianity; a pulpit; a chalice; and a baptismal font.

The mark or seal is used on the church's stationery components, vestments, stained glass windows, sculpture signs, bulletins, announcements, Bibles, hymnals, needlework, ties and jackets. Malcolm Grear Designers were also asked to design and produce a standards manual.

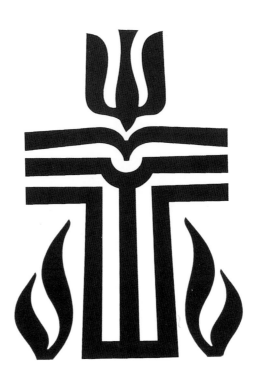

Above
To create the eight intricate symbol variations that are combined in the final logo, Malcolm Grear layered transparencies for refinements.

Left
An ingenious achievement: The final logo consists of eight different symbols (see the revelation on page 94).

"The Cross—which is the center of the symbol of the Presbyterian Church (USA) is a universal symbol of the Christian faith. The dove, one of the oldest symbols in the history of Christianity, forms the top of the cross. One of the little-noticed symbols of the Presbyterian Church is the fish. It can be seen by mentally removing the wings of the dove. The asymmetrical body of the dove then becomes a fish. The hidden quality of the fish is appropriate, for the fish was used by early Christians as a secret sign that both distinguished and revealed their identities as followers of Christ. The symbol of the book is used, since the Protestants are people of the book, the Bible. The Bible of the Presbyterian symbol lies on a pulpit or lectern, symbolizing the importance of preaching in the Presbyterian tradition. Therefore, the pulpit is the next symbol used. The cup can be seen by looking at the spine of the book and mentally removing the covers of the book at each side so that the half circle remains. The cup is supported by the central horizontal line and by the base of the cross. The cup thus becomes both a chalice and a baptismal font, symbols of the two sacraments—baptism and the Lord's supper. Another sign is the fire: four flames at the base of the Presbyterian seal draw on many biblical images of fire and light. Last, the implied triangle in the Presbyterian seal is formed by the base of the cross and the bottom and sides of the flames. It is a triangle of equal sides and comes to a peak in the center of the cup, chalice, or baptismal font, as well as the book or Bible."

—Malcolm Grear

The Cross

The Pulpit

The Dove

The Cup

The Fish

The Fire

The Book

The Triangle

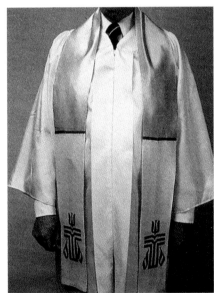

 Ontario
International Airport

 Palmdale
Airport

**Los Angeles
World Airports**

 Van Nuys
Airport

 LAX

LAX | ONT | VNY | PMD

Los Angeles World Airports

Selbert Perkins Design
Santa Monica, California

Selbert Perkins Design was commissioned to design a logo that would unify all four airports. The client asked for a strong mark that would be conversant with the average national or international traveler.

The Project
The Los Angeles Department of Airports is in charge of coordination and organization for Los Angeles's four airports. The Los Angeles International Airport, or LAX, and the Ontario Airport are international; the Van Nuys and Palmdale airports are national. The Los Angeles International Airport is among the country's largest. The previous mark for the Los Angeles Department of Airports consisted of the first three initials of the four airports. The logo was used on internal stationery but not for public collateral, and failed to communicate to an international audience.

The Briefing
Selbert Perkins Design was commissioned to design a logo that would unify all four airports. It should also be capable of representing each individual air-field as well as the group, while functioning as a public identity and an environmental mark for the way-finding system, and for signage and merchandise as well. The client asked for a strong mark that would be conversant with the average national or international traveler. In addition, the logo should be effective on internal stationery and brochures.

The Process
Selbert Perkins Design divided the process into three phases: planning, design and implementation. The planning included research, negotiations on project requirements and budget and schedule planning. It was decided that the final identity must:

- have consumer and corporate appeal;
- reflect the vision of the organization;
- strategically position the institution in its competitive environment;
- be easily understood, memorable and unique;
- not create misunderstanding in any language;
- reproduce successfully for all applications—print or environmental;
- clearly communicate in all forms of media.

In a following step, more specific identity criteria were set. It was important that the identity:

- convey a system of four airports with equal emphasis on each;
- include applications for the department versus individual airport material;
- prominently feature the acronyms of the four airports;
- reflect the theme of flight/aviation;
- reflect characteristics of southern California.

The design phase consisted of a conceptual approach, sketches, confirmation of communication elements and four presentation meetings with the client. Selbert Perkins Design decided to change the name to reflect the personality of the airports and also to make it easier to read. Nomenclature options included:

- Los Angeles Airport Department;
- Los Angeles Airports;
- Los Angeles Airport Systems;

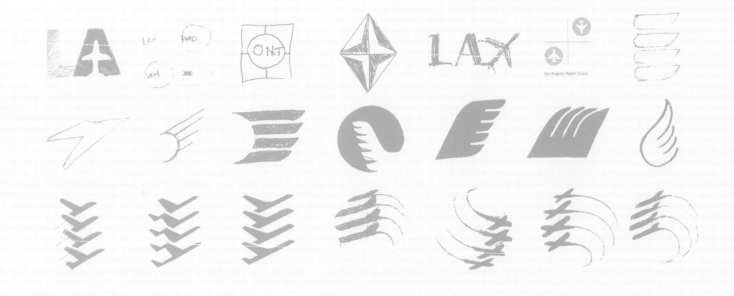

- Los Angeles Airport Group;
- Los Angeles Airport Services;
- Los Angeles Airport Resources;
- and the same proposals utilizing the acronyms.

Alternative naming proposed by Selbert Perkins included:

- LA Aviation Ports;
- LA Flight Systems;
- LA Flight Travel;
- LA Flightways;
- Aero Flight LA;
- LA World Airports;
- LA Gateway;
- Air Gate LA, and others.

The visual concept combined the four units into one unified mark. Various explorations led to the development of abstract marks. These ideas were rejected by the client due to concerns of misinterpretation. The proposed strategy focused on an iconic solution thematizing aviation and incorporating the clients' services. A majority of the research time was spent on color coding: a bright red was first conceived to represent the Ontario Airport. However, after investigation, it was discovered that this specific red is negatively perceived among Asians. The red was adjusted to a darker, warmer, more sophisticated tone. In general, a striking color coding that was not too bright was decided upon. During the implementation phase the final logo

design was revised, edited and prepared for the final presentation.

The design process took one year, from November 1995 to November 1996. Implementation of the logo varied depending upon the airport, but the logo was finally visible in all the airports by the end of 1999.

The Solution

"Los Angeles World Airports" is the new name for the four airports; it concentrates on the two international airports, LAX and Ontario. The logo features four abstract planes in a dynamic take-off position. Each airport is represented by a different color to accentuate its singularity. The employment of multiple colors favorably distinguishes the logo.

It was important to Selbert Perkins for the mark to function as a classic, enduring public identity. The logo is reproducible in black and white, and can be animated. It translates into multiple media formats, such as internal stationery, uniforms, banners and signage for transportation at the airport. Selbert Perkins's graphic layout was accompanied by a manual. The Los Angeles Department of Airports has its own in-house design department to implement these design rules on collateral material.

Indexic and iconic marks on the aviation theme were selected from the above explorations and presented to the client. These objective figures indicated a direction the client was looking for.

"The idea of not being too abstract by using the aviation theme is the same, but it got more literal, less up to the audience's imagination, less open to interpretation."
—Gemma Lawson

Above and facing page
Selbert Perkins Design explored various possibilities visualizing the aviation theme.

1–6
Refinements of promising versions of the wing theme selected from the sketches above.

1–3

4–6

7
During a presentation this logo proposal was rejected because it was too static.

8
This proposal didn't go into further development because the idea of using acronyms was too abstract for the client.

7

Los Angeles Airport Group

8

LOS ANGELES AIRPORT SYSTEM

Los Angeles
World Airports

LAX | ONT | VNY | PMD

Los Angeles
World Airports

LAX | ONT | VNY | PMD

LOS ANGELES AIRPORT SYSTEM

Los Angeles
World Airports

LAX | ONT | VNY | PMD

Los Angeles
World Airports

LAX | ONT | VNY | PMD

This later stage of the design phase shows refinements on typography and the color schemes of the previously selected marks utilizing different versions of nomenclature.

The symbol in the logo on the top left utilizes figure–ground techniques. The illusion of the plane is created using four geometrical elements, each shape in different colors representing one of the four airports.

Detroit Edison

Detroit Edison

Enterprise IG, Inc.
New York, New York

Understanding and anticipating customer needs, says DTE Energy management, is the key to becoming a market-driven enterprise. For Enterprise IG this meant a humanistic design solution for the logo.

The Project

Because a single utility company can no longer hold an exclusive electricity franchise in a particular geographic area, the Detroit Edison Company, one of the largest in the United States, was suddenly faced with major competitors for the first time. They were forced to integrate a marketing program with a new identity strategy, positioning platform and visual system. To provide greater financial flexibility and expand to unregulated, energy-related ventures in southeast Michigan, nationally and worldwide, Detroit Edison's management created a new holding company called DTE Energy.

The Briefing

Enterprise IG was hired to capture the spirit and personality of the new Detroit Edison and to communicate this to their clientele while portraying Detroit Edison as a major player in the new energy era.

The Process

Enterprise IG named the new holding company DTE Energy in order to leverage the existing Detroit Edison heritage and build upon its identity within the financial community by incorporating its NYSE ticker symbol. Increasing competition in the utility industry demanded a new positioning strategy that centered on the value offered to customers. "Success in our industry will be determined by those who serve customers well. Focusing on our customers will provide us with our greatest opportunity for success," explained former Detroit

Edison's Chairman and Chief Executive Officer John E. Lobbia. Enterprise IG started with research and interviews with Detroit Edison customers and employees. The result showed a need to improve customer service and resulted in this positioning statement for the company: "Actively working to provide energy solutions that are right for...customers by understanding and anticipating their needs."

This thinking became the basis for the creative ideas behind the new identity and visual system for Detroit Edison and DTE Energy:

- "Actively working" describes the energy necessary to propel the companies forward into the twenty-first century;
- "Energy solutions" suggests an expanded business, offering a broader set of options and energy management services;
- "Understanding and anticipating customer needs" is the key to becoming a market-driven enterprise.

The logo design process lasted approximately six to eight weeks, and included the extension of the look and feel to various systems and applications.

The Solution

Enterprise IG proposed a humanistic rather than a technical design for the new positioning strategy. Solutions for wordmarks, abstract symbols and monograms were explored.

The concept of incorporating a human likeness that was gender neutral into the logo attracted the most attention because of its representation of humanity. Features like hair, bone structure and eyes were carefully adjusted. Enterprise IG worked closely with illustrator Nancy Stahl during this phase. The face was combined with the star, or "energy Mark," to reflect the relationship between Detroit Edison and the people they serve. The human face looking confidently toward the future and the burst of energy in the background illustrate Detroit Edison's preparedness for coming times, and Detroit Edison's energy solutions for people, by people. The color blue was chosen because of its positive undertones. Blue made the face and the accompanying energy burst more approachable and charismatic. There is a link to the previous logo, although the new tone is brighter. The logo-mark for Detroit Edison and the holding company, DTE Energy, are the same and show a direct connection between the corporate and the operating capacities. The difference is purely typographic.

The logo appears on all Detroit Edison communications including line trucks, correspondence, brochures, business cards, ads and forms.

Above
The last design phase: various studies on positioning, proportion, size and line weight of the letters.

To confirm the final quality of the mark, Enterprise IG tested its effectiveness as a negative figure—an important criteria for the evaluation of any logo design.

Left
The letterheads of the new and the old logo in comparison: The "energy mark" solution (at bottom) is powerful and dynamic, whereas the former identity (at top) looks static and functional.

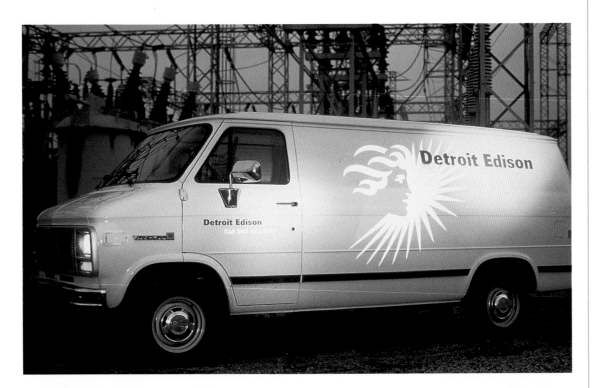

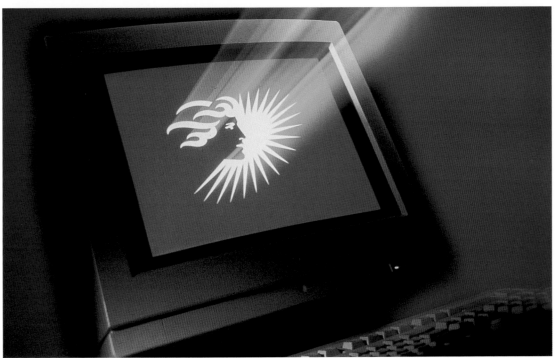

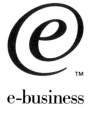

e-business

TM

e-business

IBM

Armonk, New York

The Project

With its headquarters in Armonk, New York, IBM has been a developer of advanced information technologies for over eighty years. IBM, or, International Business Machines, offers products and services to help customers improve the efficiency of their businesses.

Although the corporation has played a major role in the production and development of Internet Technology, prior to 1996, IBM had not specifically positioned itself against its Internet competitors. It was not distinguishable to Internet users. The corporation lacked a clear identity in the cluttered and constantly expanding market.

To improve their positioning, the Corporation launched a cohesive marketing initiative called e-business and identified the following paradigm: "e-business is a marketplace in which businesses use Internet technologies and network computing to securely transform their business processes, relationships and the buying and selling of goods, services and information to derive value from the Net."

The Briefing

In the early part of the first quarter of 1997, the "Corporate Identity and Design" and the "Corporate Branding" groups of IBM were commissioned to develop a branding identity for e-business that would differentiate their

Although the corporation played a major role in the production and development of Internet technology, IBM had not specifically positioned itself against Internet competitors.

products and services in the market, further aligning offerings and build a leadership position for IBM. That the new identity should position the collective Internet offerings and services from IBM was a key objective.

The Process

Lee Green, Director Corporate Design, and Mona Lentz, Corporate Design Manager, worked with IBM's Branding Team to evaluate audience perceptions of the IBM brand presence on the Net. The result showed that IBM lagged far behind many well-known browser brands.

The design team developed three branding priorities:

1. An identifier (the so called e-business Mark) to be used to signal IBM's role on their customer's web site;
2. An extension to the identity program to IBM's worldwide e-business marketing initiative (the so called e-business logo);
3. The development of e-business education materials and electronic tools which allow a simultaneous introduction to this new branding program of IBM and it's employees worldwide. With this focus on internal education, the entity was able to facilitate a cohesive implementation across all communications prior to the public announcement in the third quarter of 1997.

During the design and program development phase, the team conducted research into customer percep-

an e-business solution▸

tions specifically related to security and confidentiality, issues that play a decisive role in the acceptance of Internet services in general. Dozens of variations on a distinguished e-business Mark were considered. When shown in conjunction with the IBM logo as an e-business Mark on customer sites, customer's confidence improved. The willingness to conduct a transaction on the IBM customers' sites increased dramatically and customers were more inclined to provide confidential information. Also, customers found the simple e-business logo to be innovative and advanced.

The Solution

The new e-business logo appears in red, a signal color which allows it to be distinguished from other IBM marks. It is the first new corporate mark to be introduced since Paul Rand recreated the IBM logo twenty-five years ago. Additionally, the IBM design team built a sophisticated "e-business logo usage guideline" site for IBM employees and their creative agencies, in order to manage their important asset. This internal site provides an overview of the branding strategy and principles and offers examples of usage. It also accommodates artwork files in various formats and configurations, and promotional merchandise from golf balls to T-Shirts. A second, external site, educates the public about the new e-business idea. The e-business logo also appears in communications, advertising, and promotions.

1
The new e-business Mark, incorporated the IBM and the e-business logos with an e-business solution message.

2-5
The evolution of the IBM logotype.

IBM's web sites introduce the e-business concept to their customers. Various links direct the customer to in-depth, humorously communicated information.

Clear and bold graphics on the covers of two different brochures: The left booklet contains the explanation of the e-business concept. The right folding brochure helps customers understand the values of the new e-business Mark Program.

In this advertisement, IBM offers real customers as examples of companies who have implemented IBM e-business solutions. Each featured customer site included the e-business Mark.

Conexant

Siegel & Gale

Los Angeles, California

Through its concentric, radiating arcs, the new symbol powerfully expresses the idea of communication and migratory technology—the heart of Conexant's business.

The Project

When Rockwell International spun off Rockwell Semiconductor Systems, the new company had to announce its rebirth to the world. Beyond providing the hardware to power communications technologies, the company creates systems and solutions for its customers. A positioning statement—"What Is Next in Communications Technologies"—was initiated to convey leadership and innovation in this field. A new identity had to support this bold new Voice™.

However, the initial public offering was only two months away and, because international and cultural trademark research would take approximately five weeks, the company had only four weeks to develop a new name and identity.

The Briefing

Siegel & Gale were asked to design a new mark that would support the positioning as well as an undetermined name. It had to express:

- a bold new voice in communications technologies;
- the vitality of an organization that consisted of innovators and thought leaders;
- the leadership of a company that had been responsible for several technological firsts;
- excitement so that internal audiences could rally around it;
- the significance of the company's work;

- the company's unique personality and style;
- the essential nature of what the company does.

The identity had to work in a variety of applications, including a small semiconductor chip.

The Process

As a result of tight time constraints, Siegel & Gale had to begin with identity explorations as the name was being developed. Thus the identity was created for three potential name candidates. Any one of these candidates could be viable based on international trademark and cultural evaluations. Luckily all three possibilities began with the letter "C," so symbols could be created around this character.

Because the identity had to be used in varied applications—from chips to the Internet to signage—and legibility was crucial, Siegel & Gale decided that the new mark had to be a symbol.

Siegel & Gale began with an extensive exploration documented in large matrices. In the first work session with the client, Siegel & Gale showed all initial symbol ideas, which were divided into two sections: most of the symbols belonged to the "general exploration" and three to the "recommended symbols" section. These selected three were presented in different colors, because color decisions tend to be an emotional issue.

Two of the group of the "recommended symbols" and a third from the "general exploration" were

then chosen by the client. These three semifinalists were refined and presented again, each proposal in a variety of colors. To help the client visualize the marks within its identity systems, Siegel & Gale dropped the candidates into a number of prototypes.

Finally, one mark was selected for further refinement. By this time, the new name—Conexant—was also fixed. Mock-ups were developed.

The Solution

Through its concentric, radiating arcs, the new symbol powerfully expresses the idea of communication and migratory technology—the heart of Conexant's business.

In four weeks, an identity had been developed, approved and submitted for an international trademark and cultural evaluation.

Bank of America

Bank of America

Enterprise IG, Inc.
New York, New York

There was no clear winner until the idea of combining the symbology of a flag with a rural landscape was generated. This "flagscape" direction captured the "coast-to-coast" scale of the bank.

The Project

In 1998, NationsBank and Bank of America, merged to form the first nationwide, coast-to-coast bank. Under the name Bank of America, the newly formed financial institution serves the financial needs of individuals, businesses, government agencies and other financial organizations throughout America and around the world.

With an increase in size, scope and services, Bank of America needed a new corporate identity.

The Briefing

The design scope for new branding was to visualize Bank of America's successful banking domain, nationally and internationally. Also, Enterprise IG was asked to create an identity that would be easily recognizable, yet very different from the two former bank logos. The identity program had to appeal to diverse audiences, from retail to affluent to corporate.

The Process

Enterprise IG's work was organized into three primary brand categories: brand name, brand building and brand positioning. Within twelve months, the key objectives—brand name and brand positioning, which are dependent on a rigorous discovery process—had to be developed simultaneously. Schedule constraints required a major effort in team building and coordination. The multi-discipline Enterprise IG team helped the client assemble a precise task force to address the com-

munication issues, decide content and produce the products that would position this new identity as instantly identifiable.

Through discussions, it was discovered, that the positioning needed to address notions such as action, passion and the courage to handle customers' banking business.

The name selection, however, was one of the most challenging parts of the whole project. Enterprise IG explored every naming option, while proceeding with the entire branding and design process. NationsBank had very high name recognition and brand equity. However, Bank of America had a clear advantage across several market segments and was seen as possibly the most powerful name for a financial institution in this country, and leader of "free" world commerce. The name was not finalized until the very conclusion of the project.

Enterprise IG's recommendation for the logo design was to create a very simple, not too smart or complicated and very essential symbol for immediate recognition.

Initial design explorations focused on symbols over wordmarks. To represent America, the range concentrated first on the obvious: flags with stars, stripes and fireworks in red, white and blue, etc.

There was no clear winner until the idea of combining the symbolism of a flag with a rural landscape was generated. This "flagscape" direction captured the "coast-to-coast" scale of the bank and the hardworking personality of the employees. Since the targeted audience is so wide-ranging and therefore responds to different stimuli, colors and influences, the imagery was to be designed to accommodate the audience, the message and the singular brand all at once.

The Solution

The final design is a symbol of the landscape of America—woven, flexible and suggesting movement. It's a combination of an American flag and an arrow pointing to the future. It intends to capture the spirit of local communities as well as the strength of their global capabilities. Additionally, it intends to signify Bank of America's passion for the hard work of today, as well as their commitment to planning for the growth and prosperity of tomorrow.

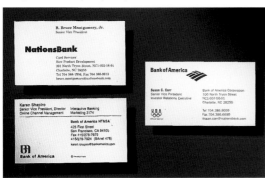

1–3
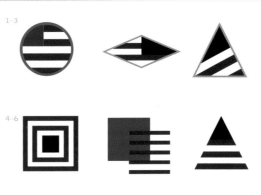
4–6

7–8

9
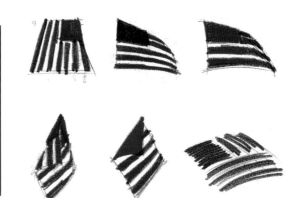

Above
The lines of the new "flagscape" symbol extended, form the basis for the corporate identity's grid system (see also page 112).

1–8
Various explorations on abstractions of the American flag and its colors.

Far left
The former business cards of the two merged banks in comparison to the new identity (right), which has a strong dynamic and future-oriented articulation.

9
These sketches visualize the development from the flag to a modern "flagscape" concept.

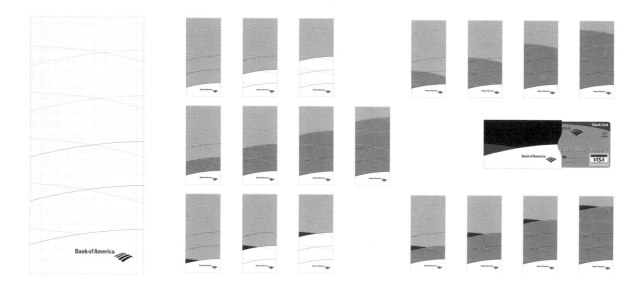

Above
The new design manual:
it's grid system is derived
from the new symbol and
allows for maximum
design flexibility to all
applications from print
to web to environmental.

10
The grid system in
combination with the logo
gives Bank of America a
progressive look. The new
corporate typeface is Meta.

11
The final version
of the new Bank of
America symbol.

From this symbol, the foundation of the overall visual system layout was derived — a curved grid on which the entire balance of color, images and text were organized to form the brand signature.

With this assignment, Enterprise IG experienced the most tightened time constraints ever. With presentations from coast to coast and quick decisions made to meet the fixed schedule, the process became blurred.

The project was kept highly confidential until the implementation launch, which was realized worldwide in one day in signs, printed material, advertising and electronic media.

When implementation is complete, Bank of America will have over 4,500 banking centers and more than 13,000 ATM's across the country..

10

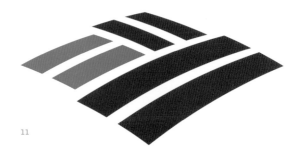

11

12

10, 12 and 15
On customers' brochures,
the new Bank of America
logo always appears on a
light background, whereas
the dimensions of the back-
ground are variable and
depend on the subject of
the application.

13

15

13–14
On signage and ATMs,
the positioning of the
"flagscape" symbol is
more centered.

16
Whether on stationery
or on Web sites, the grid
with the wave-like lines
is a successful solution
for any media.

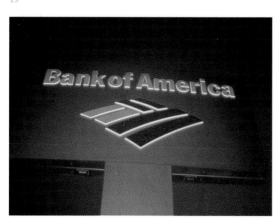

14

16

ACADEMIC INVESTIGATIONS

Texas Instruments

Carnegie Mellon University, School of Design
Pittsburgh, Pennsylvania

Robert Swinehart and Fred Murell of Texas Instruments communicated the following task to the students: Design a new mark for Texas Instruments that utilizes the idea of a virtual identity, rethinking and identifying Texas Instruments' positioning for the future.

The Project

Robert O. Swinehart is professor of design and former head of the communication design department at Carnegie Mellon University and teaches classes in corporate identity. The idea for a project collaboration with Texas Instruments evolved from Swinehart's extensive research in current movements and criticism in contemporary corporate identity and design. "What is apparent," says Swinehart, "is a feeling that the old fifties and sixties model of strict corporate ID programs, requisite identity manuals and design police to dictate design policy is probably outdated, at least in large companies." New technology, multimedia and constant changes in our lives demand different approaches to identity. Swinehart scrutinized the idea of the "monolithic corporate identity" and observed that "if corporations are to cope with change, their communications must adapt and reflect their ability to be flexible, yet still 'speak with a corporate voice.'"

"Print communications have been joined with electronic media and will eventually encompass most of our senses, including sight, sound, taste, smell and even tactility. Corporate identity can no longer be a mere graphic image of a company, but should represent the entire corporate soul: What was, is, and will be, expressed as a flexible identity." Swinehart refers to the word "virtual" in "virtual reality" to describe the dynamic quality of a new generation of strategic corporate design, coining the term "virtual identity."

During this research period, Swinehart met with Fred Murell, the director of Design and Strategy Worldwide at Texas Instruments. Opinions on the future of corporate identity and the need for flexible solutions were shared. This exchange became the basis for a student project at Carnegie Mellon University.

The Briefing

Robert Swinehart and Fred Murell communicated the following task to the students: Design a new mark for Texas Instruments that incorporates the idea of a virtual identity and identify Texas Instruments' positioning for the future.

The project emphasized a mark that could have an infinite number of structural variations to represent specific subsidiaries, divisions, or the cobranding of products. Also, remaining adaptable for the multitude of tailored needs in the future, the attributes of the mark had to embody the values and personality of the corporation. The ultimate flexible and adaptable "parent mark," that Swinehart called the "virtual mark," and the tailored combinations of additional marks were explained as part of a "virtual identity" (VI) program.

The Process

Fred Murell made periodic visits to the class, sharing his expertise. He provided background material from Texas Instruments and gave critiques to the work-in-progress. Considerable time was spent tun-

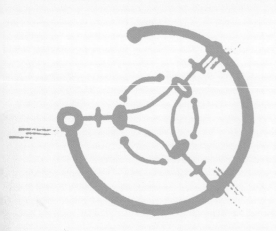

ing the students into a new way of thinking. As a result, a new language and terminology was developed. Scenarios were envisioned to build and project futuristic concepts that could be used as material for the design process. Written as well as group scenarios were brought into play to describe hypotheticals that Texas Instruments was interested in. The research phase also included key-word listings and slogan building that were used as techniques to identify a direction for problem-solving. Consequently, the company name was scrutinized.
It is somewhat ambiguous: Texas Instruments is an international corporation with a worldwide reputation, yet the name indicates regional (Texas) roots. The proposed solution employs the acronym TI as a graphic qualifier. The abbreviation is easy to recognize and allows for optimum design flexibility.

Approximately one-third of the seventeen-week semester was spent on building a virtual identity knowledge base; directions that Texas Instruments was in the process of defining for itself were discussed. The last two-thirds of the term were spent developing parent marks and representative samplings of the "family members" in static form. Following this phase was the application to a kinetic medium. This gave life to new "family offspring" inconceived in the static domain. A prototype of the kinetic form was developed in Macromedia Director. Color and sound were options to be explored at a later time.

The Solution
The virtual identities served two different purposes. First, to meet the academic requirements for a typical sign, symbol and mark class. Secondly, the solutions were intended to offer TI self-reflection and a better understanding of how to shape their future.

At the end of the project, a documentation included the VI concept, a proposed solution for TI, a grouping of "family members," co-branding and a visual history of the design process. The solutions were dynamic, virtual-identity concepts, including sketches that were to be considered as a stimulus for further discussion with TI.

Although the project remained an experiment for TI, it was very successful and was repeated every year for third-year communications design students at Carnegie Mellon. Since Fred Murell left TI, the project has continued with different companies.

Above
One student scrutinized open and closed cells as metaphor for a new TI parent mark.

Left
A cover designed for a documentational book at Carnegie Mellon University overviews the diversity of the projects for Texas Instruments.

LANNED HAND

MAN / INDIVIDUAL

GLOBE HAS AN
EARTHY QUALITY

Above
A student's question:
Should a virtual logo
be structured like
a simple cell?

Right
Explorations on symbols
for Texas Instruments's
key components.

CELLS & CELL STRUCTURES

change greater reach and
accessibility values

values change

recreation **situation**

you control/customize
your life intelligent
environments

communication **work**

change values

values change
more variety in your
experiences/choices

ti

ti **ti**

ti **ti** **ti**

This solution is the result of the same project conducted three years later, when TI had already changed its own mission. TI described themselves to the students as a leader in improving life through coordinated technological innovation instead of being just a producer of technology of consumer products. During meetings with the students, TI described future environments as "technological ecosystems" in which TI could develop endless numbers of related technologies that would transform all of our lives. This identity shows "a variety of soft, organic and digital environments distinguishing the family members, while looping lines of differing weights and descriptions activate the environments. The major line has four nodes that represent recreation, communication, work and situation. The environments are intended to be somewhat fuzzy and allusive as the future is not clearly describable....It is intended to be technological, but still [alludes to] the hope of the future. The qualifier is a dramatic lowercase 'ti' that is structurally strong and nontraditional in character," comments student Ravi Hampole on his graphics for a TI identity.

Right
This storyboard shows
how Rachael Nass's soltion
for a virtual identity for
TI would be animated.

"My parent mark shows
that TI encompasses
technology. The amorphic
shape relates to a form
that can fit into a human
hand. TI can fit into
your hand. It is something
you can grab and shape to
your needs. The form indi-
cates that TI's technology
is accessible instead of
being intimidating. This
mark is flexible and
dynamic like the future. It
is flexible to suit your
individual needs. This
parent mark incorporates
the qualities of the entire
family of marks. These
marks represent a company
that is technological,
human centered, personal,
global, innovative and
connected. TI is involved
with people and invites
you to take hold of
technology."—Rachael
Nass's mission statement
for the TI identity

Left
Rachael Nass developed
several cobranding marks
that would be used for
TI's subsidiaries. Their
specific shapes are based
on the design of the parent
mark (see opposite page).

The Los Angeles
PHILHARMONIC

The Los Angeles Philharmonic

Jean Lee
Pasadena, California

Sometimes two or three different logo treatments were applied in one season with different ad directors and mixed graphic styles for each program. A cohesive identity was needed to fuse the Philharmonic and the Hollywood Bowl in the public's mind.

The Project

The Los Angeles Philharmonic was founded in 1919 by multimillionaire and amateur musician William Andrews Clark, Jr. Today, with the leadership of the young conductor, Esa Pekka-Salonen, it is among the world's top orchestras, with performances at home and abroad.

Uniquely, the Philharmonic offers two attractive locations for its performances. The winter residence is the Dorothy Chandler Pavilion in downtown Los Angeles, soon to be relocated to the Walt Disney Concert Hall designed by architect Frank Gehry. The summer season concerts take place outdoors at the Hollywood Bowl, where visitors can dine during the performances. The programs of the Philharmonic include concerts and symphonies for children and young adults, Chamber Music Concerts, and Celebrity Recitals featuring world-renowned musicians.

Although the Los Angeles Philharmonic and the Hollywood Bowl are both run by the Los Angeles Philharmonic Association, their communication materials and overall identities were diversified to reflect the various activities of the orchestra; however, this approach lacked unity. Sometimes two or three different logo treatments were applied in one season with different ad directors and mixed graphic styles for each program. A cohesive identity was needed to fuse the Philharmonic and the Hollywood Bowl in the public's mind.

Michael Buckland, the marketing director of the Philharmonic Association, had seen the results of an Art Center College Graphics Project and decided to initiate a collaboration with Greg Thomas, acting chair of the school's graphics department. Buckland and Thomas generated a project for a senior class that would function effectively as a competition. The objective was to end the class project with the selection by the Los Angeles Philharmonic of one of the students' proposals. The selected designer would then have the opportunity to continue to work with the Philharmonic, oversee the implementation and application of the new identity and be rewarded with a paid internship.

The Briefing

The Los Angeles Philharmonic Association asked the students to develop:

- a consistent, enduring corporate image for the Philharmonic's interlinked entities and activities;
- an innovative, strategically based program that could be a relaunch for the organization or could even lead to a name change;
- a look that attracts younger audiences without alienating current concert-goers, who, on average, are about fifty and older;
- an appropriate look for the internationally recognized music organization, while still reflecting its California roots;

- an abstract visual language without traditional symbols such as musical notes, instruments or images of conductors or orchestras;
- a cohesive concept identifying that the Philharmonic and Hollywood Bowl events are derived from the same mother organization;
- a graphic solution that suggests the move from the Dorothy Chandler Pavilion into the new Walt Disney Concert Hall in 2001.

The Process

Fifteen senior design students participated in the fourteen-week-long project. The syllabus developed by Greg Thomas and Michael Buckland provided for several presentations with board members of the Los Angeles Philharmonic, as well as visits and discussions with musicians.

During the first sessions, the Philharmonic staff was consulted, and students used the input to define a strong background for ideas. Existing logos from philharmonics around the world were researched and scrutinized. These provided further insight into the specific field. The result revealed that the standard identity of a musical organization employs in some way notes or instruments. The challenge was to find visual abstractions for music and a musical orchestra without being too literal. The project structure therefore evolved an in-depth analysis of music and its meaning.

Another task was the reconciliation of the different aspects of the Los Angeles Philharmonic—the festive event—and the Hollywood Bowl—the more casual event. Should they be graphically treated as separate entities? Should the graphic characters of the two logos be from the same family or should they be put under one "umbrella" logo?

The first series of ideas were shown to a panel during the midterm review. The students had two major positions on how to approach a logo concept. One strategy was to develop separate marks for the Los Angeles Philharmonic and the Hollywood Bowl that could then be consolidated to form one single logo,

Above
Initial marker sketches originated from basic geometric forms, such as circles and squares. These helped define the shape and proportion of the logo.

Left
The October 1997 issue of Los Angeles's "Performing Arts" magazine featured the new Philharmonic logo. Jean Lee was asked to design a harmonious abstraction of the new identity.

Above
A later phase of marker sketches reveals final curves of the logo.

Right
A second (right) and third (below right) design phase explore different axes, angles and line weights for the circular shapes of the logo.

as in the yin and yang symbol, to represent the Los Angeles Philharmonic Association.

The other direction was to create one mark with distinguishing colors for the Hollywood Bowl and the Los Angeles Philharmonic. Representatives of the Philharmonic gave their input for refinement: both directions were further developed. For the final presentation seven weeks later, the students had to produce a list of deliverables: e.g., their logo ideas applied to stationery, tickets and billboards. The Los Angeles Philharmonic Association also requested a design manual that would explain the sizes, proportions, colors and positioning of each individual's logo idea.

Far right
Once the right shapes and proportions were found, Lee recreated the final logomark in Adobe Illustrator.

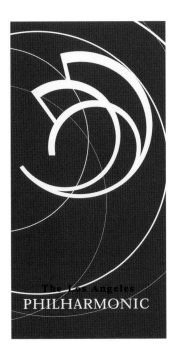

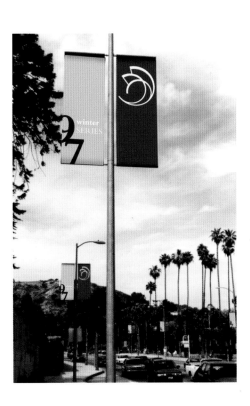

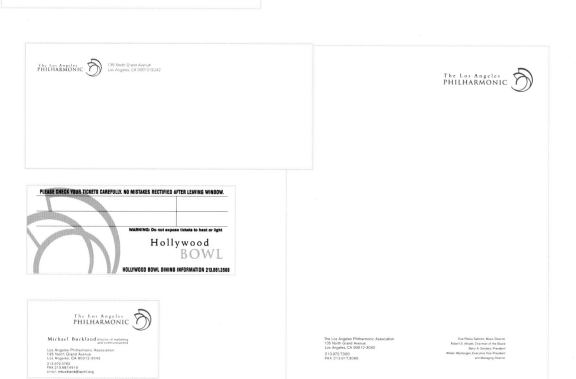

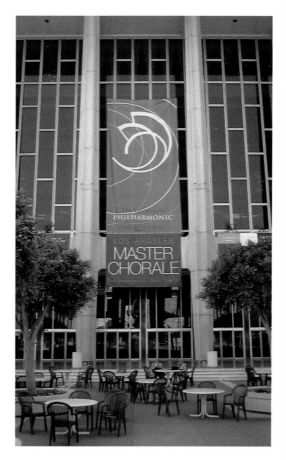

At the end of the fourteen-week project, all fifteen students had to give a ten-minute presentation to a panel that included Philharmonic Vice President and Managing Director Ernest Fleischmann at the Dorothy Chandler Pavilion. From these fifteen, four identities were chosen for presentation to the executive committee of the board of directors for the Philharmonic.

The Solution

The logo submitted by student Jean Lee was approved by the Board as the final winning logo. Her idea is based on the whole note, a basic element of music. The note's elements are implied through an abstract form and a series of circles. Various angles and sizes characterize the dynamics of the orchestra and the contemporary composition. The design also harmonizes with the distinctive curves of the plan of the Hollywood Bowl and the fanciful shapes of Frank Gehry's design for the Disney Hall. It communicates both music and movement. A central consideration in Lee's concept was to represent the Hollywood Bowl, the Los Angeles Philharmonic and the other musical events with only one mark. Lee demonstrated that one symbol can successfully portray a multifaceted organization. The colors alone indicate specific usage: For the Los Angeles Philharmonic application, Lee chose blue, a color representing consequence and sophistication. The Hollywood Bowl is defined in the complementary color, orange, to symbolize summer, sunlight and lightness.

Jean Lee worked together with the Philharmonic during the launch of her logo design, defining applications such as the first season of banners and advertisements.

Above
Oversize advertisements on Los Angeles's streets show strong, witty slogans. The overall minimal design doesn't compete with the fine graphics of the logo.

Left
Lee's work at the Philharmonic included the flag that hangs at the Dorothy Chandler Pavilion, the winter home of the Los Angeles Philharmonic.

R35 LLC | Raymond Pirouz

In order to address this question properly, I will have to identify the two major phases of logo, icon and symbol design:

1. Conceptual Phase—In this phase, the designer studies the communication challenge at hand and begins the process of research, brainstorming, strategic thinking, planning and sketching to arrive at a series of potential visuals from which the optimal creative solution evolves.

2. Production Phase—In this phase, the concept sketch (or storyboard) is cleaned up, refined and produced as camera-ready art (for traditional print graphics), an EPS or TIFF file (for computer-based graphic and print applications) and as JPEG, GIF, animated GIF and vector art (for Web-based content from pixel-based still images and simple animations to dynamic vector graphics via Macromedia Flash).

Novice designers allow the technology to dictate their conceptual strategy, which is a mistake, in my opinion. As you can see by the breakdown (left), professional designers know that the conceptual (strategic and creative) phase of the process remains unchanged no matter what the application. Therefore, when developing logos, icons or symbols for any application, one must concentrate on the design challenge at hand, which ultimately always deals with a specific message that needs to be communicated to a certain audience in an engaging, visually stimulating, informative and memorable fashion.

When the visual has been created using traditional methods (i.e., making sure that the concept is strong, ensuring that the weights of the graphic are proportionate and that it scales beautifully and displays well in both color and black and white), the resulting artwork then needs to be optimized for the delivery medium at hand. For print-based work, trapping and CMYK color consistency considerations must be made. By the same token, Web/screen design requires that the Web-safe palette be observed and that considerations be made for users with slow connections (by way of file size optimization schemes). The Web/screen design difference does not stop here, however. The Web offers the next dimension in visual communication not previously available to the print-based medium.

1. Interactive story-telling and brand management. In print, the designer has one chance to make a positive first impression. The logo can be displayed in a certain color or with a hit of varnish, for example. In the interactive arena, the logo can come to life as an animation, telling a story and helping to create a memorable branding experience for the visitor. If executed properly, this can translate to a more compelling delivery of a brand message with a choreographed beginning, middle, end and even back to the beginning (in the form of a loop).

2. "Live" content updated on the fly as information changes. Print creates "dead" content in that once the material is off the press, it is pretty much old news. In the interactive arena, content can be updated and enhanced on the fly, thereby creating a more fluid and sustainable vehicle for information delivery.

Web/screen design opens up an entire new world of possibilities (many of which have not yet been discovered) to speed the evolution of the design profession. Understanding basic design principles and knowing how to apply them to the growing number of visualization outlets is the key to long-term success in this evolving field.

Logos on Screen

Five designers answer the important question:

How does the design (of logos, symbols and icons) change with the existence of Web/screen-based design?

The future of logo design raises new questions relating to technological advancements now and in the twenty-first century. Just as the PC revolutionized design in the twentieth century, the world of the Internet, computer animation and motion graphics will revolutionize the way we develop and use trademarks.

We posed the question on the left to five top designers working in these fields; this section contains their answers.

Netscape | Laura Neuman

The design process has been affected in a few key areas:

Compressed Schedules
Internet time is a harsh reality when designing for electronic media. The extraordinary pace and frequency of change demands that designs be executed more quickly with much less information or direction than in the past. Internet brands have achieved an extraordinarily high level of awareness in much less time than ever before. As a result, the infrastructure in the corporation to develop and manage a brand is being built at the same time as the identity is evolving.

Incompatibilities in Hardware
Limitations in screen resolution, incompatibilities in color palettes across platforms and users' ability to adjust contrast and brightness on their monitors creates an environment where the designer can't predict what the final design will look like.
If the task is to design for a cross-platform world (like Web sites), designers should understand the basic difference between hardware platforms and monitor resolutions.

Cost
Cost of the development of screen real estate for commercial Web sites is a real premium. Developing icons and symbols is costly; they use significant amounts of space on the screen and often fail to communicate any more effectively than text. The global implications with Web sites create a challenge for the designer as well. Icons and symbols do not usually translate well to an international audience.

Simple Navigation
Important criteria for designing navigation systems for Web sites have to be kept as simple as possible. It's important to always give the user a clear way back to the start of the page. It is wrong to assume that a user can learn a navigation system and remember it unless the site is designed as a game and is intended to take users on a hunt. The navigation system should be used as consistently as possible throughout the site. The navigation system should be thought of not only as a functional means to get around the site, but also as part of the site's identity.

> "The navigation system should not only be thought of as functional means to get around the site, but also as part of the site's identity."
> —Laura Neuman, Netscape

Qwer | Iris Utikal, Michael Gais

For us, the conceptual and contextual connection between client and logo has priority within the design process. This always will be the same, independent of the technological changes in computer graphics. The design possibilities within the different media, though, have multiplied because of Web and screen design, and allow, or better yet demand, new developments. The technological limitations (color palette of screens, memory and resolution) are restrictive and bring you back to reality. On the other hand, we see a challenging advantage: because of tight limitations, coming to a satisfying solution requires a high level of creativity.

> "We always try to start with a mark that looks good and is conceptually smart, even as a still frame."
> —Kyle Cooper, Imaginary Forces

Malcolm Grear Designers | Malcolm Grear

The Web does not change things at all in terms of the design process for the design of a symbol. It means that this is simply another application. I like to think that we never design a logotype, which may include a symbol or icon, in a vacuum. All types of applications must be considered—large, small, 3D and possibly 4D, embossed, de-embossed, engraved, animated— and in many cases for use on everything from bill-boards and architectural signs (sometimes neon) to lapel pins and Web sites. In other words, it's very often not just a stationary system. As an example, at the 1996 Centennial Olympic Games, our sports pictograms were applied to every imaginable medium, ranging in size from $\frac{1}{16}$ of an inch on Swatch® wristwatches to 30 feet on sides of build-ings, from popcorn bags to neon. Good design is good design! Web-based design is fantastic in terms of a tool for applications: we can rotate, animate, make dimensional studies, we can move around and under things, we can deal with time. As a negative, it is extremely difficult to deal with real subtleties needed in a symbol on the computer. This is one of the most exciting and challenging periods ever

Imaginary Forces | Kyle Cooper

With Web design you have the added element of watching the logo unfold in time. This provides an opportunity for narrative. Yet the design process is not entirely different from print. We always try to start with a mark that looks good and is conceptually smart even as a still frame. From there we think of how it can evolve onscreen to support the message. Playing with the reveal/ resolve of a logo animation is a great way to make the symbol memorable with an element of surprise or drama. In a way, you get a chance to squeeze more information into the same small space, by planning for a fourth dimension—even if the icon is just spinning, blinking or cycling. The most important criteria for the design of web tools is getting the message. Icons are great when you understand their meaning right away.

for the designer. We are able to face squarely and help shape the consequences of change in this digital age. And we change, shaped by our explorations.

Working side by side with mathematicians and scientists, we will labor in the realms of infinity— much more ornate than three dimensions. For navigational tools for the Web, the most important criteria is the fact that navigation through space or through text is made up of textual or iconic direc-tionals. Since space is really nonexistent on the Web, navigation on the Web is more akin to book navigation—finding hierarchies, colors, type weight, type style and page arrangement or layout. But the similarities are blurred. Where every one of us has picked up and thumbed through a book, the video-based experience of Web navigation places a contraption between us and information. My hand sometimes feels as if it is reaching into a Plexiglas box. I am separated from the information.

Information can become a placid eye staring back through the Plexiglas box at me. The separation is interesting, though. It allows our minds and our eyes to be lured into an interaction with choices. But, too often, these choices are condescending. They are often too didactic. Ugly buttons dictating a way to go. This is sophomoric, just as would be writing "door" on a door. Or setting a folio that reads "This is page 22." To involve people with Web design, to permit this luring, we have to appeal to them as they need to find their way, but we must do so with the understanding that curiosity can be satisfied and important information relayed by providing distinct graphical choices while per-mitting people to move around, to discover, to inter-act. It is the interaction and discovery process that is unique to the Web. I make a selection and for a moment I don't know what to expect. Cues, clues and hierarchy make that moment sustainable —anticipation doesn't overwhelm the design. People respond to color, placement, text, image and envi-ronment on the Web as we do in other spatial and textual environments. We are tuned in to finding our way with color changes, type sizes. These are as functional on the Web as anywhere. Although time is an important factor, and movement and color shifts can be tactfully done, still it comes down to the ease and the pleasure of finding our way.

"Working side by side with mathematicians and scientists, we will labor in the realms of infinity—much more ornate than three dimensions."
—Malcolm Grear,
Malcolm Grear
Designers

Icon and Graphic Button Design
Allen-Bradley and Rockwell Software
Agnew Moyer Smith

The Project
Allen-Bradley (A-B) and Rockwell Software are subsidiaries of Rockwell Automation. Allen-Bradley is a world leader in programmable logic controllers, industrial automation software, motion control and electronic interface devices. Rockwell Software offers development and support of automation software, providing supervisory control software, "windows-based" packages for real-time industrial trending and more.

The two affiliated companies were developing "windows-based" software products to control and monitor assembly lines and other processes in highly automated manufacturing settings. These were intended for the same end-user groups. But because they were generated by different people working in different locations, there was a risk that inconsistencies—where the same idea or function is represented in different ways—would occur and cause confusion for the end user and increase the time required to learn and use Allen-Bradley/Rockwell Software products. It was decided to involve a design corporation to help control visual adherence.

The Briefing
Agnew Moyer Smith was asked to eliminate incohesive elements and standardize the graphical user interface (GUI) across all software products by creating a library of highly legible, intuitive and standardized icons and graphic buttons. The goal was to enable software developers to draw upon this library when creating new applications, rather than "starting from scratch," and to finally guarantee a better product for end users.

The Process
Over several years, AMS worked closely with Allen-Bradley and Rockwell Software product managers to conceive of graphic buttons, icons, splash screens and artwork to support the user interface of their products. In creating the interface library,

AMS followed the principles of traditional symbol sign design, but within the narrow confines of the digital world, which limits the designer to a small area measured in pixels.

In the ideation phase AMS developed and applied:

- metaphors and familiar objects to give users an immediate understanding of a button's function (a magnifying glass on a button represents zooming in for a closer view);

- clear shapes to help distinguish objects at a glance;

- elimination of details;

- consistency in use of symbols (e.g., a computer was always depicted as a square);

- consideration of context to guarantee a button or icon was delivering the right message;

- international suitability by accommodating cultural differences.

To design specific icons and buttons by these principles, AMS generated a six-step process for A-B and Rockwell Software product managers to follow when initiating a design request, reviewing alternatives, and receiving final files to include in their software applications.

1. Receive spec sheet.

The process began with a product manager providing AMS with a specification sheet for the icon or series of icons. The sheet detailed all performance and usability requirements, including a working name, a functional description and clues about the icon's use and context.

2. Develop name, number and description.

AMS evaluated the request and interviewed the product manager to obtain additional details. Each icon or graphic button would then be formally named, assigned a file name (defined by a consistent formula) and a one-line description of the icon

would be written, which was often used in the status bar of the application or in the Help file. Writing the description was a successful way to distill the icon's function to its most primary feature.

3. Sketch alternatives.

Using an Icon Design Sheet, AMS generated appropriate metaphors to communicate the function of the particular button or icon. The sheet gave designers the freedom to quickly sketch ideas without technical constraints of the computer—an effective way to generate related alternatives that could be lost or overlooked in the time needed to create pixel maps on the computer. For efficiency, the sheet also contained a grid that allowed the designer to test ideas in a simulated "pixelized" environment.

4. Develop concepts in an icon editor.

After exploring ideas conceptually on paper, the best sketches were tested on the computer using an icon editor program, with only a few pixels to work with (only 19 x 17 pixels in the case of a graphic button). The icon editor forces the designer to eliminate any unnecessary detail that initial sketches might contain. The program also makes it clear what ideas are viable for on-screen display. It allows the designer to work with "fat bits" at a large scale while at the same time viewing the icon at its actual size. The icon editor also allows the designer to view five other designs to evaluate alternatives side by side, or view the design with other graphic buttons or icons that it may be paired with. Often, one has to learn that a seemingly great idea can't be achieved on a graphic button without compromising the detail that made it great in the first place.

5. Review and approve.

Once the icon or graphic button was created, a human factors specialist and the software developer reviewed it for modifications or approval.

6. Finalize files.

After receiving approval, AMS translated the graphic button to various formats as required by the application. Every icon and graphic button was added to an icon catalog to make it ready for distribution and inclusion in all software applications.

Each graphic button was considered individually as well as in relation to its specific button/icon family and evaluated to meet standards and guidelines.

With only 19 x 17 pixels to work with, all detail that does not aid communication had to be eliminated; for example, decoration often obscures, rather than clarifies, a graphic button's meaning. AMS had to consider that the icons and buttons would be viewed on monitors with different resolutions—from Super VGA to a monochrome liquid crystal display. A principle was to accommodate the worst-case scenario and to keep items from becoming too small or too close together. Often, the tightest constraints were the best challenge for the designers and were the basis for the production of most successful buttons/icons.

The Solution

AMS created an easy-to-use, consistent resource for the companies' software developers that, in addition, ensured a better product for end users. Along with providing electronic files for the various icons and buttons, AMS created a catalog to allow developers to quickly see what was available. This catalog also provided guidelines for developing new icons and buttons, which some of the developers would need to do, following the established standards and conventions for design and naming.

What is the difference between graphic buttons and icons?

Graphic buttons generally appear on toolbars and palettes within a software application and are associated with a particular feature or function of that application. A user clicks on a graphic button to perform a task. Icons generally appear on computer desktops—a user double-clicks an icon to launch an application. Icons are also used within applications—in dialog boxes, for example—to signal information or events that users need to pay attention to.

An excerpt from a volume of over two hundred icons and graphic buttons AMS designed for Allen-Bradley and Rockwell Software for use by the companies' software developers.

Consistent visual language: AMS ensured all related graphic buttons used the same consistency in theme/size/shape and positioning. If one button used a square to represent a computer, all other buttons had to use a square to represent a computer in that context. This meant the user only had to learn and remember a symbol once, and could apply that same learning to decipher other buttons. Shown right is a series of graphic buttons to depict the attributes of various types of common, factory-floor push buttons. Arrows and the button visual were kept in the same scale and position to allow developers to quickly determine similarities and differences and choose the right button for their task.

Use of Metaphors:
When possible, AMS used familiar metaphors and common objects to describe complex functions and operations. This helps users intuitively understand the button's function. Here, AMS used an odometer-like counter to represent a window that receives dynamic numeric data from a factory-floor machine. A magnifying glass represents the idea of viewing a document at an enlarged size. And an icon for a TagEditor application leverages the common practice of physically "tagging" the location of equipment on the factory floor by depicting an old-style factory tag.

Care with color:
Sometimes the icons AMS designed would appear on monitors and screens that could only display black and white. AMS had to pay special attention to ensure colors and grays would translate to a monochrome environment. The graphic button shown on the left appears fine in situations where users can see gray tones. But in a black and white display mode, the image of the printer becomes an indistinguishable blob. Choosing light and dark colors wisely, as the third button shows (below left), allows the image to maintain its integrity on a monochrome display.

Internationalization:
Allen Bradley and Rockwell Software products are marketed and sold in many countries outside the United States. They must allow for local language translations as well as be sensitive to cultural nuances. AMS focused on ensuring the images for buttons and icons were appropriate and communicated the intended message in cross-cultural situations. For example, in some countries, pointing the index finger (left icon) is a rude gesture. Instead, AMS eliminated the context of a pointing finger and substituted a closer view of the hand (right icon), while still maintaining the same visual clues.

Clear shape in visual theme:
Agnew Moyer Smith's task was to design not only single icons, but also icon families to represent the Allen-Bradley software suite. Here, each icon stands for a software application that allows users to configure and manage control devices and drives on a factory floor. AMS used a consistent visual theme—a person interacting with devices and objects—to unify the relationship among the products. When possible, icons are drawn as three-dimensional objects. This aids in image recognition and improves the icon's effectiveness in communicating a message. Depicting objects at angles increases the sense of dimension, makes the icons look more dynamic and allows for clear identification.

Agnew Moyer Smith
503 Martindale Street
Pittsburgh, PA 15212
USA
www.agnewmoyersmith.com

Alexander Isley Inc.
4 Old Mill Road
Redding, CT 06896
USA
www.alexanderisley.com

Art Center College of Design
1700 Lida Street
Pasadena, CA 91103
USA
www.artcenter.edu

Carbone Smolan Associates
22 West 19th Street
New York, NY 10011
USA
www.carbonesmolan.com

Carnegie Mellon University,
School of Design
5000 Forbes Avenue
Pittsburgh, PA 15213
USA
www.cmu.edu/cfa/

Chermayeff & Geismar
15 E. 26th Street, 12th floor
New York, NY 10010
USA
www.cgnyc.com

Enterprise IG, Inc.
570 Lexington Avenue
New York, NY 10022
USA
www.enterpriseig.com

Evenson Design Group
4445 Overland Blvd
Culver City, CA 90230
USA
www.evensondesign.com

frog
frogdesign inc.
1327 Chesapeake Terrace
Sunnyvale, CA 94089
USA
www.frogdesign.com

GTA
Gregory Thomas Associates
2812 Santa Monica Blvd. #201
Santa Monica, CA 90404
USA
www.gtabrands.com

IBM
Corporate Design Department
1 Corporate Road, Route 100
Armonk, NY 10589
USA
www.ibm.com

Landor Associates
1001 Front Street
San Francisco, CA 94111
USA
www.landor.com

Leonhardt Group
1218 Third Avenue
Seattle, WA 98101
USA
www.tlg.com

Malcolm Grear Designers
391 Eddy Street
Providence, RI 02903
USA
www.mgrear.com

MetaDesign plus GmbH
Bergmannstraße 102
10961 Berlin
Germany
www.metadesign.com

MetaDesign San Francisco
350 Pacific Avenue, 3rd Floor
San Francisco, CA 94111
USA
www.metadesign.com

Nike
One Bowerman Drive
Beaverton, OR 97005-6453
USA
www.nike.com

Pentagram
204 Fifth Avenue
New York, NY 10010
USA
www.pentagram.com

Pentagram
387 Teharna Street
San Francisco, CA 94104
USA
www.pentagram.com

Qwer
Office for Communication Design
Lindenstraße 82
50674 Köln
Germany
www.qwer.de

R35
Raymond Pirouz
2275 Huntington Drive, Suite 170
San Marino, CA 91108
USA
www.R35.com

Selbert Perkins Design
1916 Main Street
Santa Monica, CA 90405
USA
www.selbertperkins.com

Siegel & Gale
300 S. Grand Ave, Suite 2500
Los Angeles, CA 90071
USA
www.siegelgale.com

Skolos Wedell
529 Main Street
Charlestown, MA 02129
USA
www.skolos-wedell.com

Vrontikis Design Office
2707 Westwood Blvd
Los Angeles, CA 90064
USA
www.35k.com

Index

Creative Director
Gregory Thomas

Editor / Project Director
Kathrin Spohr

Book Design
David La Cava

Cover Design
Julian Bittiner

Editorial Support
Thanks to Todd Hayes for his contribution.

Special thanks to Lynn Haller and Linda Hwang of
North Light Books for their patience and guidance
on this project.

Fonts
Steile Futura (1954) designed by Paul Renner
Bell Gothic (1938) designed by Chauncey H. Griffith